WEYMOU PORTLAN IN 50 BUILDINGS

JOHN MEGORAN

AMBERLEY

First published 2016

Amberley Publishing, The Hill, Stroud
Gloucestershire GL5 4EP

www.amberley-books.com

British Library Cataloguing in Publication Data.
A catalogue record for this book is available from the British Library.

ISBN 978 1 4456 6500 9 (print)
ISBN 978 1 4456 6501 6 (ebook)

Origination by Amberley Publishing.
Printed in Great Britain.

Contents

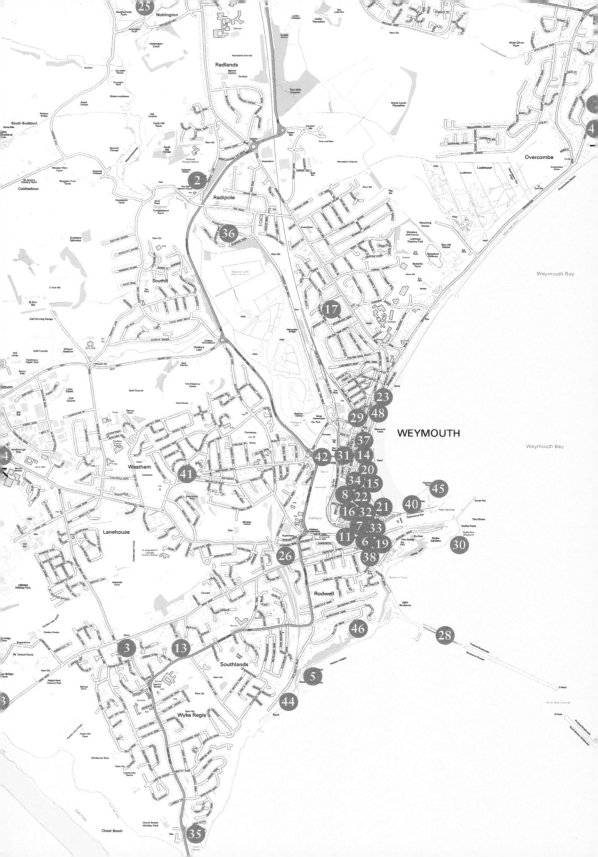

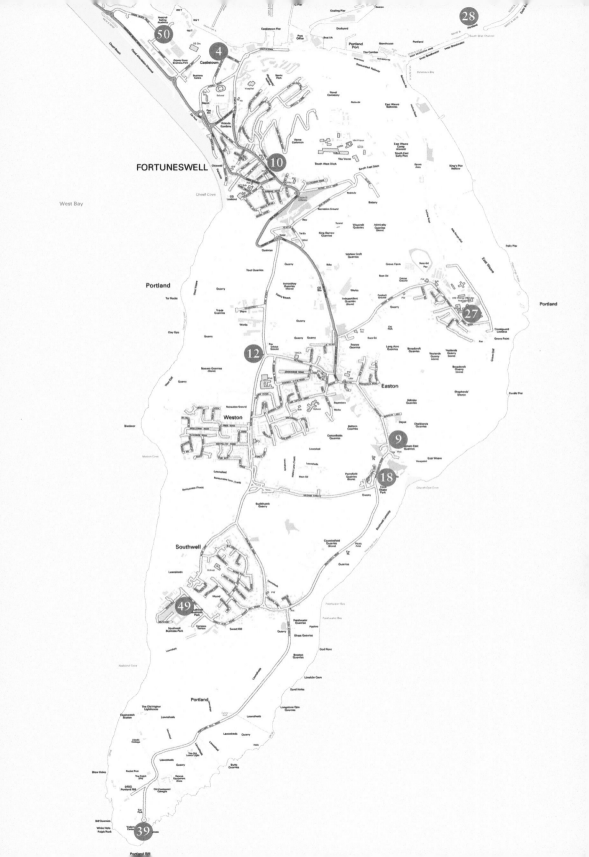

Key

1. Roman Temple
2. St Ann's Church
3. All Saints' Church
4. Portland Castle
5. Sandsfoot Castle
6. Tudor House
7. Tudor Buildings
8. White Hart
9. Avice's Cottage/Portland Museum
10. Queen Anne House
11. Ralph Allen's House
12. St George's Church
13. Belfield House
14. Gloucester Lodge
15. Harvey's Assembly Rooms
16. Eliot's Bank
17. Lodmoor Barracks
18. Pennsylvania Castle
19. Cove Cottages
20. King's Statue
21. Devonshire and Pulteney Buildings
22. St Mary's Church
23. Brunswick Terrace
24. Holy Trinity Church, Fleet
25. Octagonal Spa House
26. Workhouse
27. Portland Prison
28. Portland Breakwaters
29. Weymouth Railway Station
30. Nothe Fort
31. Thomas Hardy's Lodging
32. Working Men's Club
33. Cosens & Co.
34. No. 77 St Mary Street
35. Whitehead's Factory
36. Abbot's Court
37. Royal Hotel
38. Brewery
39. Portland Bill Lighthouse
40. Pavilion Theatre
41. Westham Council Houses
42. Westham Bridge
43. Wyke Regis Bridging Camp
44. Old Castle Road Developments
45. Pleasure Pier
46. Portland House
47. Riviera Hotel
48. Pier Bandstand
49. Admiralty Underwater Weapons Establishment
50. Weymouth and Portland National Sailing Academy

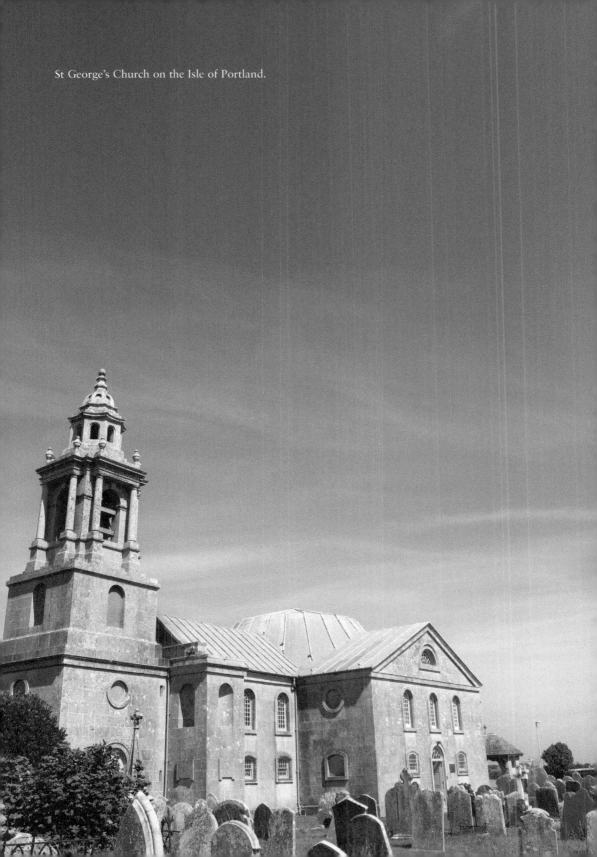

St George's Church on the Isle of Portland.

Introduction

I was born in Weymouth. Although I have spent much of my adult life away doing other things, I have been a regular returnee and now live in my home borough once again. Over all those years, Weymouth and Portland have never been far from my thoughts. Whenever I have felt a little bit down, the perfect antidote has always been to imagine myself walking along the promenade, mooching about the harbour or breathing in the tang of salty sea air at Portland Bill. This lovely part of Dorset has such a captivating allure that it seems to me to have a curative capacity capable of combatting most ills.

What we know as Weymouth today started out as two separate boroughs with Melcombe Regis on the flat and low-lying peninsula, barely above sea level, to the north of the harbour with the original Weymouth to the south. Melcombe Regis was granted a charter of incorporation by Edward I in 1280; Weymouth achieved its status as a borough in 1318. For the following 250 years the towns remained separate and sometimes prickly towards each other with regular arguments resurfacing, most particularly about harbour rights.

They became united as the Borough of Weymouth and Melcombe Regis in 1570 with the first wooden bridge connecting the two built shortly after that, replacing the earlier rope-drawn ferry. Over the years, outlying villages were absorbed and, in 1974, Portland, which had been a royal manor in Saxon times, was added with the whole conglomerate being renamed the Borough of Weymouth and Portland.

There are very few buildings in the area dating back before Tudor times. There are not a lot before 1750 when the arrival of Bath entrepreneur Ralph Allen unleashed a genie, which led to a steady building programme transforming Georgian and Regency Weymouth into a distinguished seaside resort with some of the finest architecture of its kind anywhere in Britain.

The arrival of the railway in 1857 gave another boost, and coupled with the naval developments at Portland this led to a building programme in the Victorian and Edwardian eras, including providing new homes for the expanding workforce. The depression of the 1920s and 1930s brought its own problems and solutions. The closure of the naval dockyard in 1995 was unwelcome for many but the aftermath propelled the town towards centre stage for the sailing Olympics.

It has been hard choosing just fifty buildings given that there are so many worthy of inclusion. The late and great Eric Ricketts produced no less than four volumes of his hugely informative and somewhat idiosyncratic *The Buildings of Old Weymouth and Portland*.

What I have tried to do is weave a narrative by selecting buildings that tell the story of Weymouth and Portland and some of the people, from all walks of life, who lived in, visited, wrote about, painted or helped to transform the resort. It is a fascinating story about a fascinating town.

The 50 Buildings

1. Roman Temple, AD 350
Jordan Hill, DT3 6PL

The Romans came to Dorset in AD 43, first encountering the local Durotriges tribe at Maiden Castle. They stayed for 400 years. As long as the locals were compliant and paid their taxes, they were largely left alone or integrated into the new order.

Dorchester became a significant Roman town, Durnovaria, and the River Wey was used as a port with galleys sailing up to discharge their cargoes near Radipole. Roman remains have been found throughout the district.

First excavated in the nineteenth century, this temple is thought to date from towards the end of the Roman occupation and to have incorporated an earlier Celtic religious site. It was surrounded by walls with a central sanctuary rising above a columned portico. To the north is a burial site in which eighty skeletons were found in wooden and stone coffins, also containing personal items, some of which are now in Dorchester Museum.

As the Romans came under pressure from primitive Germanic tribes, they packed their bags and went home in the fifth century. It would be another 1,400 years before anyone once again installed fresh water supplies, drains and sewers to a standard that the Romans regarded as normal.

Roman Temple.

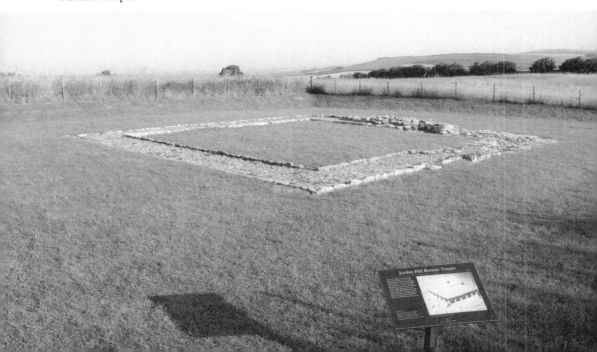

2. St Ann's Church, 1250

Radipole, DT3 5HT

In the ensuing centuries, other invaders came and went, unleashing varying degrees of savagery. In AD 790, a delegation sent to welcome the first Viking longship had their heads chopped off for their trouble.

It was not until 800 years after the Romans left that anyone put up a structure in Weymouth of sufficient solidity to last to modern times. This is St Ann's Church, Radipole, the nave of which dates from around 1250, making it the oldest complete building extant in the borough.

The north and south chapels and chancel date from the fourteenth century; the west front was rebuilt around the time the adjacent manor house went up in the sixteenth century; the porch was added in the eighteenth century; there was major restoration in the nineteenth century and the vestry is from recent times.

The walls are Ham Hill rubble stone with dressed quoins and there is an unusual Italian-style belfry on top dating from the sixteenth century.

Originally the mother church of Melcombe Regis, it was superseded in this role when St Mary's was built in the town. Over the road a small schoolroom was added in 1840.

St Ann's Church, Radipole.

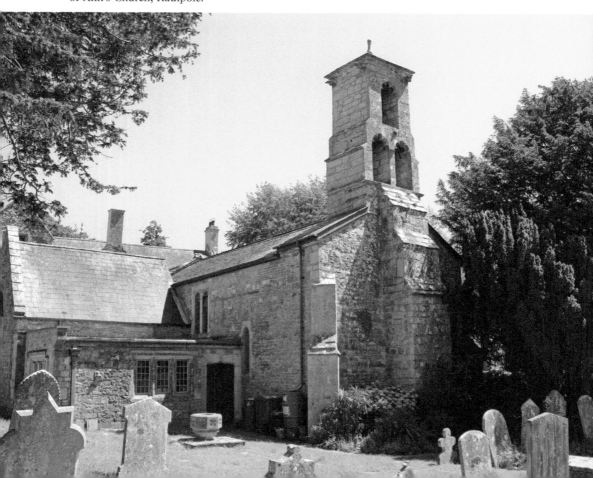

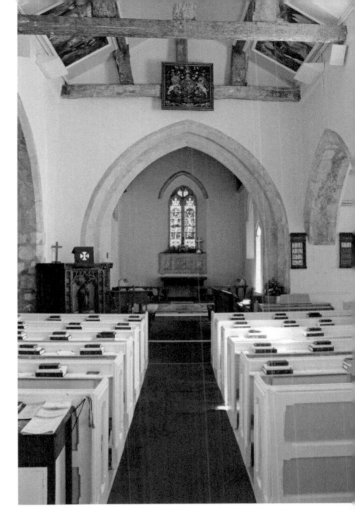

The interior of St Ann's Church.

3. All Saints' Church, 1455
Wyke Regis, Portland Road, DT4 9ES

Rebuilt in the fifteenth century, All Saints' Wyke Regis was rededicated in 1455 in the reign of Henry VI, as Weymouth's mother church. It is most unusual in that pretty much nothing has been added to, or taken away from, the basic structure since it was built. Even the massive five-layered wooden south door is original. The walls are of ashlar stone and have parapets with moulded copings adorned by various suitably hideous gargoyles.

Inside there are more intriguing figures on the walls carved in stone as corbels, including a face with toothache, a builder with a hod, and a dog with a bone. There are many memorial tablets, including one to Charles and Hannah Buxton who died aged eighty-eight and ninety-six in 1847 and 1855 respectively, reminding us that, although the average age of death may be going up, not all our ancestors died young.

Capt. John Wordsworth, brother of the poet William, is buried in the graveyard along with others who were drowned when his ship the *Earl of Abergavenny* struck the Shambles Bank off Portland and sank in Weymouth Bay in February 1805.

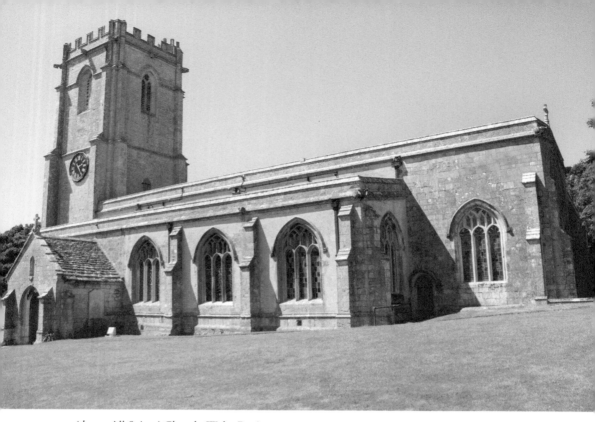

Above: All Saints' Church, Wyke Regis.

Below: Inside All Saints' Church.

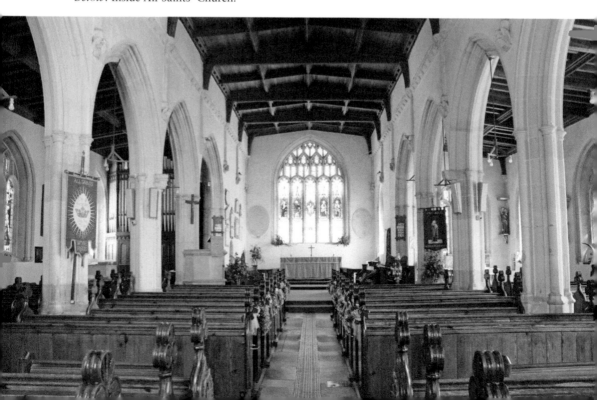

4. Portland Castle, 1540
Liberty Road, DT5 1AZ

Henry VIII was married to his first wife, Catherine of Aragon, for twenty-four years. Among various miscarriages, Catherine gave birth to one daughter, who became Mary I, 'Bloody Mary', but no son to be heir to the throne. If there had been a son, Henry might never have divorced Catherine against the wishes of the Catholic Church and English history would have taken a very different course.

Henry's marriages to five subsequent wives gave him one male heir, who ascended the throne as Edward VI, aged nine, but who died at sixteen, and another daughter, who became Elizabeth I, Gloriana.

Although Henry's advisors cooked up a legal justification, the divorce was not approved by the Pope. Henry retaliated by establishing himself as head of a new Church of England and followed that by dissolving the monasteries, appropriating their considerable wealth for the Crown.

Catholic Europe was incensed and invasion seemed possible. To guard against this, Henry commanded a string of fortifications to be built along the coast from the Humber to Milford Haven. Portland Castle and Sandsfoot Castle are two of them.

Portland Castle, which was completed in 1540, is of a radial design with a gun platform topped with an embattled parapet overlooking Portland Roads. Behind is a two-storey building with wings including a central hall and kitchen. Separately at the back were a brewhouse, stables and the sutler's house, from which stores for the castle were ordered.

Fortunately the invasion never came and Portland Castle saw no action in Henry VIII's time. However, it did see some fighting during the Civil War when it was on the side of the Crown and used as an ordnance store and prison. By the eighteenth century, it had fallen into disrepair and by 1816 had become a private residence.

Portland Castle.

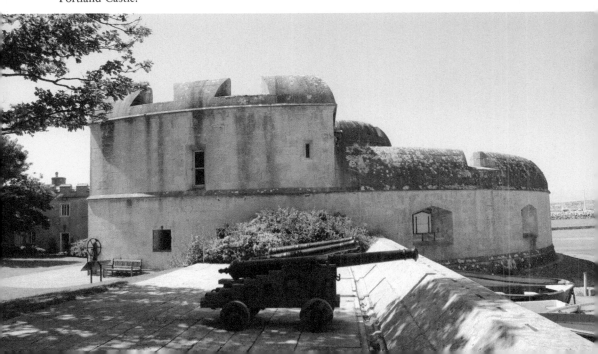

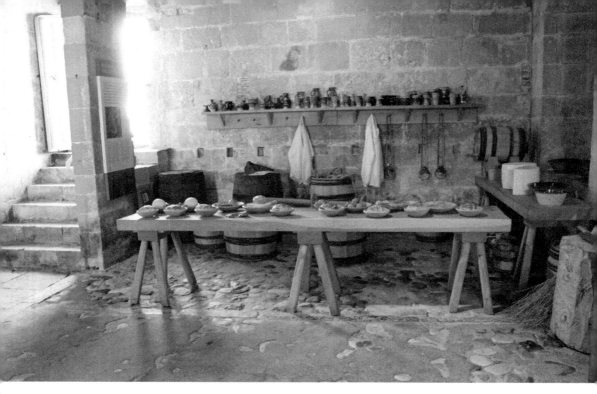

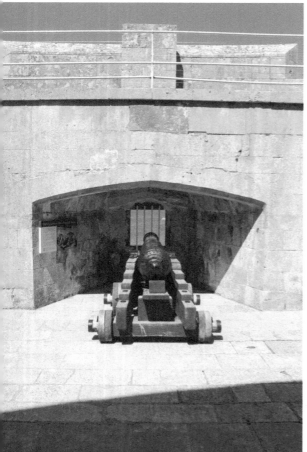

Above: Portland Castle kitchen.

Left: Portland Castle's gun platform.

The castle was back under military control in the First and Second World Wars. Today, it is owned by English Heritage and is open to the public as a fine example of a complete Tudor castle.

5. Sandsfoot Castle, 1541
Old Castle Road, DT4 8QE

Sandsfoot was the second of the two Henry VIII castles built to protect Portland roads. It dates from 1541 and is of a different design to the one at Portland. The main accommodation, which is all that is left of the original, is of a rectangular shape with two floors and a basement. Beyond that, an octagonal structure containing the gun platform faced onto the sea.

The inner walls are of Portland rubble and remain to their original height but most of the outer ashlar facing has been taken away over the centuries by locals to be incorporated into other buildings. There is a nice poetic justice here as much of the original stone had been plundered from Bindon Abbey, near Wool, when it was closed in Henry VIII's destruction of the monasteries.

The base of the cliffs at Sandsfoot tend to be washed away by rainwater draining down through the topsoil and escaping to the beach at the bottom, creating gaps into which the cliff above falls. Less than fifty years after it was built, the castle was said to be in poor repair and work was needed to make good the damage. Today, the whole gun platform has gone, although the last bit to fall off in the 1950s remains visible on the beach below.

Sandsfoot was first in the hands of the Crown in the Civil War, during which time it served as a local mint, but it was taken by Parliamentarian forces in 1644 and continued to have a use as a storehouse until towards the end of the seventeenth century when it was abandoned.

Sandsfoot Castle.

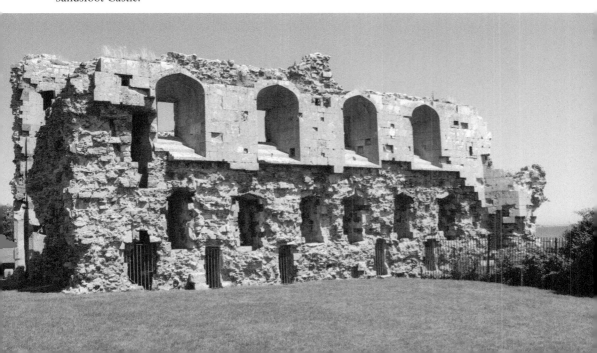

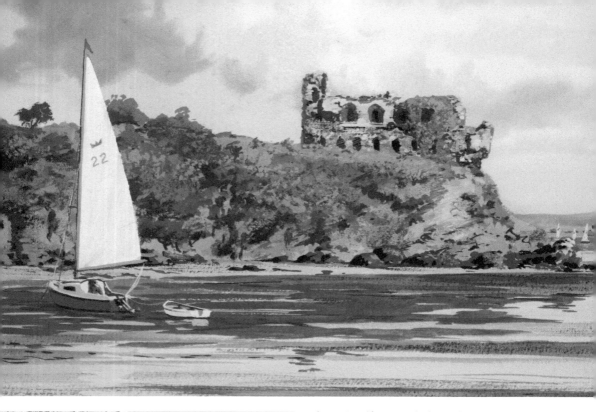

Above: Sandfoot Castle from the water.

Left: Inside Sandsfoot Castle.

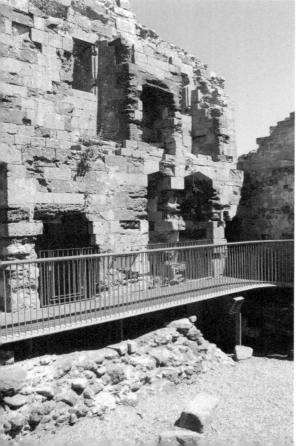

As Weymouth developed as a fashionable seaside resort for the rich in the late eighteenth century, the castle became a desirable destination to which the aristocratic tourists came to potter about and admire the ruins. Its popularity has continued and it is now a regular stop-off point for those on the 'Rodwell Trail' who can enjoy a cup of tea and a bun from the kiosk in the gardens while they admire the view.

6. Tudor House, c. 1600
3 Trinity Street, DT4 8TW

The Tudor House is thought to have been built for a local merchant of some distinction. It has a Portland-stone ashlar façade with stone kneelers, is built over three floors and was originally on the harbour side before that part of the cove was filled in during the latter part of the eighteenth century. Up until then, this part of Weymouth was the centre to which the great and the good among visitors gravitated to stay and be entertained at what is now called The Old Rooms on the opposite side of this street a few paces north.

After George III's brother, the Duke of Gloucester, built Gloucester Lodge on the Esplanade in 1780, the focus turned to that side of the river and this area of old Weymouth declined in importance.

The Tudor House was saved from proposed demolition by local architect Mr E. Walmsley-Lewis, who bought it with his own money and fitted it out with furnishings from the seventeenth century after the Second World War.

Now owned by Weymouth Civic Society, it is open to the public at selected times and provides a fascinating insight into how people lived in Weymouth in late Tudor times.

Tudor House.

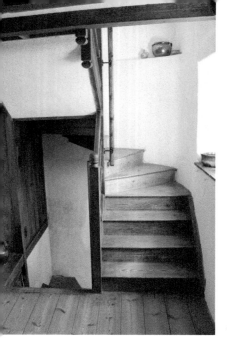

The Tudor House staircase.

7. Tudor Buildings, c. 1600
St Edmund Street, DT4 8AS

The L-shaped buildings from the Duke of Cornwall extending round the corner to the Ship Inn by the harbour date from the early seventeenth century. Built with two storeys and attics under a slated roof, they have gables with corbelled kneelers and parapets plus copings that end in scrollwork. All these fancy bits of detail indicate that money was no object when these houses went up.

Another and later decorative feature on the east side is a cannonball in the outer wall where it struck during fighting between the opposing sides in the Civil War of the 1640s. During this fractious conflict, all of Weymouth and Portland was first on the side of the king. Then the Parliamentarians took Weymouth, Melcombe Regis and Sandsfoot Castle, leaving Portland and its castle in Royalist hands. The Crabchurch conspiracy tried and failed to take back Weymouth for the Crown. By 1649, Charles I had had his head chopped off and all the country was under the Parliamentarian rule of Lord Protector Oliver Cromwell.

At the beginning of the seventeenth century, in the last knockings of good Queen Bess's glorious reign, tolerance, good humour and gaiety had been in the air with a liberated view of drinking, dancing and love. Shakespeare was writing his plays and sonnets, holding up a mirror to the realities, joys and sorrows of what it is to be a human being.

Less than fifty years later, Cromwell's Puritan England was a different land. Taverns and theatres were closed down. Any form of merriment was frowned upon. It became a crime punishable by death for a married man or woman to engage in sexual activity with anyone other than their legal spouse. Neighbours started to denounce neighbours. Witch-hunts were on the up.

The L-shaped buildings declined in status as the years rolled on with the one on the corner becoming the base for Weymouth's fire pump in the nineteenth century. In 1951, a revamp converted the ground floor into a public convenience, which Eric Ricketts described rather charmingly as 'a necessarium'.

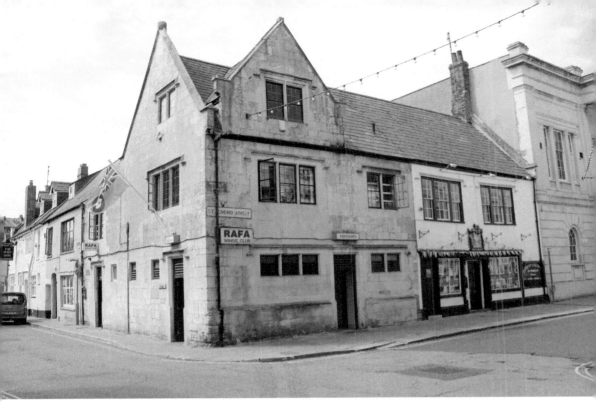

Above: Tudor Buildings, St Edmund's Street.

Right: Cannonball in the wall.

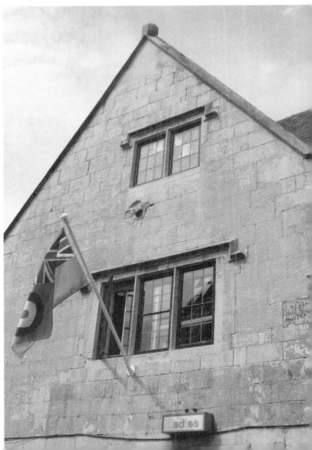

8. White Hart, c. 1600
New Bond Street, DT4 8LY

The White Hart was built in the early seventeenth century with two storeys plus attics and ashlar walls partly rendered in stucco. There are gable kneelers and the chimney stacks have a moulded and dentil cornice. The house had a garden that extended to the Backwater. To the north, Bond Street, which was then called Coneygar Lane, contained a ditch into which waste was tipped. James Thornhill was born in the house in July 1675.

The latter part of the seventeenth century was an era of contrasts. On the one hand, scientists like Newton, Hooke and Boyle were laying down the foundations of modern physics. On the other, there were still many prosecutions and trials of witches. The split between Catholicism and Protestantism, unleashed by the divorce of Henry VIII, rumbled on after the Restoration with the rather too pro-Catholic James II eventually replaced in 1688 by an imported Dutch Protestant, William III, and his English wife, Queen Mary II.

Thornhill was ten years old when the Duke of Monmouth landed with troops at Lyme Regis in a first attempt to unseat James II. The rebels were defeated and tried at Judge Jeffreys's notorious 'Bloody Assize'. Gallows were built at Greenhill with the prisoners hanged, drawn and quartered, a particularly unpleasant death as executioners knew just how to keep their victims alive for as long as possible during the extended and painful process.

As a boy, Thornhill showed a real talent for art and became a high-society painter, decorating the interiors of many notable buildings including the Painted Hall at Greenwich and the inside of the dome of St Paul's Cathedral.

White Hart Tavern. *Inset*: White Hart's gable kneeler and chimney with dentil cornice.

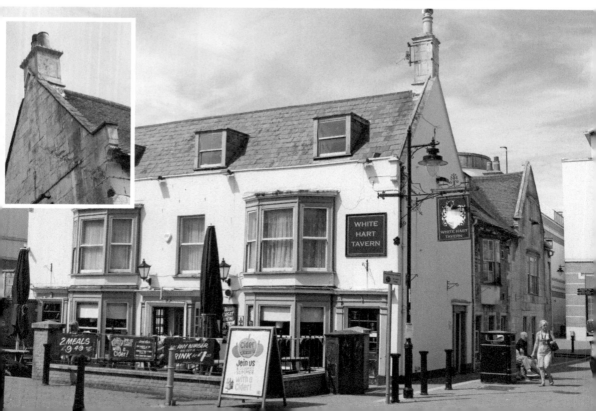

He retained connections with his hometown, becoming one of Weymouth's four MPs from 1722 to 1734. Knighted in 1721, he donated his painting of *The Last Supper* to St Mary's Church and, with his own money, built almshouses for 'decayed mariners' on the site of the old cattle pound at the north end of St Thomas Street.

The east front of the White Hart was completely rebuilt in the nineteenth century. Some original internal features, including the stone staircase and decorative plaster ceilings, survived into modern times.

9. Avice's Cottage/Portland Museum, 1640
No. 217 Wakeham, DT5 1HS

Although Portland is attached to the mainland by Chesil Beach, the connection is not made until Abbotsbury, 8 miles to the north-west, so the only practical way of getting to and from it was by boat until the first bridge was built in 1839. The community on Portland was therefore somewhat cut off and inward-looking, often regarding outsiders, or 'kimberlins', with varying degrees of hostility, which occasionally included throwing stones at them.

Today, Portlanders have a much more welcoming approach but the island itself retains a feeling of being a different place, with its captivating bleakness made starker by the dearth of large and ancient trees. It contains a wealth of old buildings, including many stone cottages dating back to the seventeenth century like these two in Wakeham adjacent to the path down to Church Ope Cove.

Avice's Cottage.

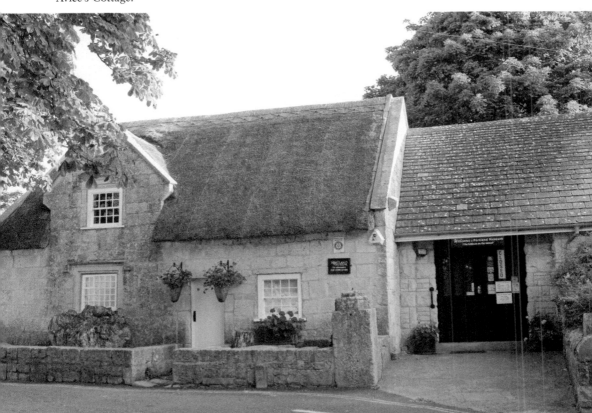

Built of stone with a thatched roof, the end cottage has one storey and an attic with the front wall carried up to a gable over the attic window. It was built in 1640 and modified in the eighteenth century to include a new stone fireplace.

Often referred to as 'Avice's Cottage', it features in Thomas Hardy's novel *The Well Beloved*, a tale of Portland boy Jocelyn Pierston who goes out into the wider world as a sculptor but who comes home often over a forty-year period during which he falls in love successively with three generations of young girls all called Avice – grandmother, mother and daughter.

Dr Marie Stopes came to Portland in 1922 and lived initially in the old Higher Lighthouse before buying these two cottages. Stopes is best remembered for her pioneering work on women's rights and birth control. She had other interests too including fossils and the now deeply unfashionable subject of eugenics.

In 1930, Stopes founded Portland Museum in these cottages and this remains in a refreshed form containing many fascinating artefacts that tell the tale of Portland's long history. It is well worth a visit.

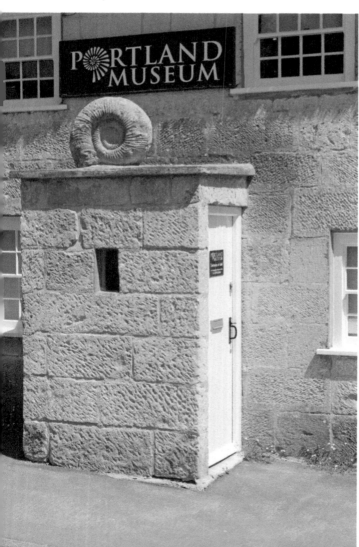

Portland Museum with
fossilised ammonite.

10. Queen Anne House, 1710
No. 4 Fortuneswell, DT5 1LP

Sir Christopher Wren, who became one of Weymouth's MPs in 1701, lived in turbulent times: he was a teenager during the Civil War. After the Restoration, he lived through the reigns of five subsequent monarchs. He was thirty-four when London was overwhelmed by plague. The following year, the Dutch raided the Thames and Medway, carrying off our flag-ship and London burnt down.

This bit of bad news for London turned out to be a real game-changer for Portland as Wren made its stone the building material of choice for many of his grand projects, including the rebuilding of St Paul's Cathedral, as well as other churches after the fire.

Portland stone had already been in use elsewhere. Inigo Jones took it up for the Queen's House at Greenwich, and there are plenty of other examples, but it was Wren who transformed the quarrying on Portland to an industrial scale with no less than 50,000 tons of its stone being shipped out by sea up to London for the building of St Paul's Cathedral alone.

Delays and other problems delivering a sufficient quantity when needed led the king to decree that all Portland stone should be used exclusively for this project until it was finished and that no stone could be quarried without a licence from Wren.

All this work was a major boost to the local economy and made money for Wren's man on the ground, the local quarry boss Thomas Gilbert, who became sufficiently wealthy to build Queen Anne House in Fortuneswell around 1710.

Whether or not Wren played any direct part in its design is unknown but it has his fingerprints all over it with its plain ashlar façade, consoled and rusticated front door and aprons under the first-floor windows.

Queen Anne House.

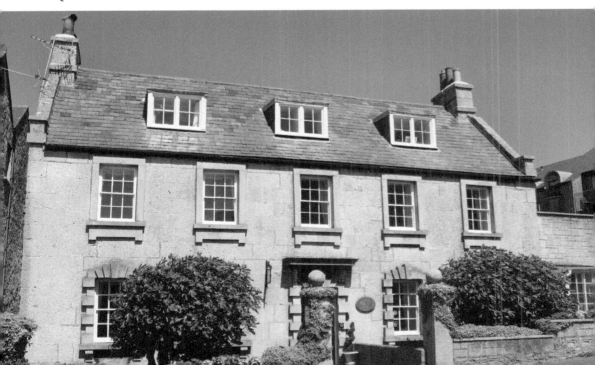

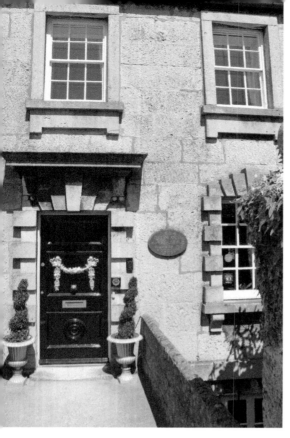

Queen Anne House front door.

Currently, Queen Anne House offers bed and breakfast facilities, thereby providing the opportunity to stay in what must surely be one of the finest examples of a town house of the period anywhere in England.

11. Ralph Allen's House, 1750
No. 2 Trinity Road, DT4 8TJ

No. 2 Trinity Road was bought in 1750 by Bath tycoon Ralph Allen, who had made two fortunes: one from developing an efficient postal service and the other from quarrying the distinctive honey-coloured smooth stone for which Bath is renowned.

Allen spent several months each summer in Weymouth in succeeding years until his death in 1763, inviting and entertaining his friends, including George III's brothers. From this, word spread of the therapeutic wonders of Weymouth.

By the middle of the eighteenth century, bathing in, and drinking, seawater was seen as a medicinal tonic. However, the closest seawater to Bath in the Bristol Channel had its problems. With a rise and fall of 16 metres, the tidal range is huge and this massive quantity of water coming in and out twice a day causes dangerous currents.

Weymouth, on the other hand, has one of the smallest tidal ranges anywhere in Britain going up and down by a mere 2 metres, even on big spring tides. It also has a wonderful beach with fine-quality sand that shelves so gradually that it is hard for anyone to get out of their depth.

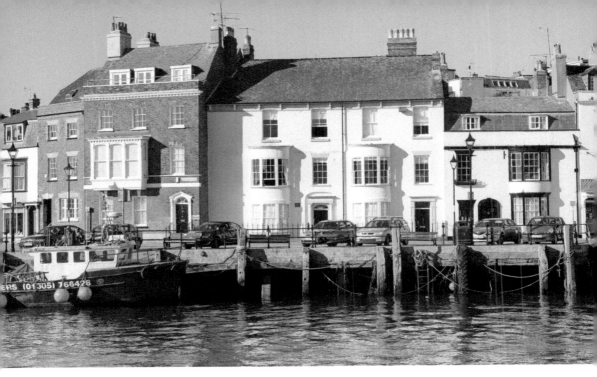

Above: Ralph Allen's white house in the middle now with three storeys.

Right: Ralph Allen's front door.

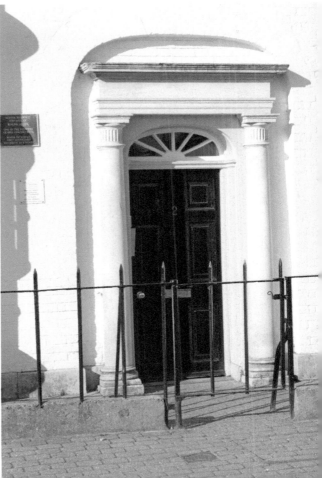

Weymouth also has two other advantageous tidal factors. On a roughly biweekly cycle, the biggest high tides occur around 8 a.m. or 8 p.m. The lowest of low tides are around 1 a.m. and 1 p.m. just when, in the afternoon anyway, everyone wants to be on the beach.

There is also the local tidal phenomenon called Gulder. At low water, the tide starts to come back in just a little bit, stands for a while and then goes back out before coming back in properly. This gives an extended low-water period again, maximising beach space just when people most want to use it.

Allen's Weymouth house has a central doorway with Doric columns on each side and a fanlight set between two elliptical bay windows. In the late nineteenth century, it was divided into two houses and had an extra storey added. Today it is a holiday let.

12. St George's Church, 1766
Portland, DT5 2JP

A casual observer might think that St George's Church was designed by Christopher Wren. However, the architect was Thomas Gilbert, grandson of the Thomas Gilbert who built Queen Anne House. The young Thomas knew Wren, visited London and absorbed the latest in architecture and design.

St George's Church.

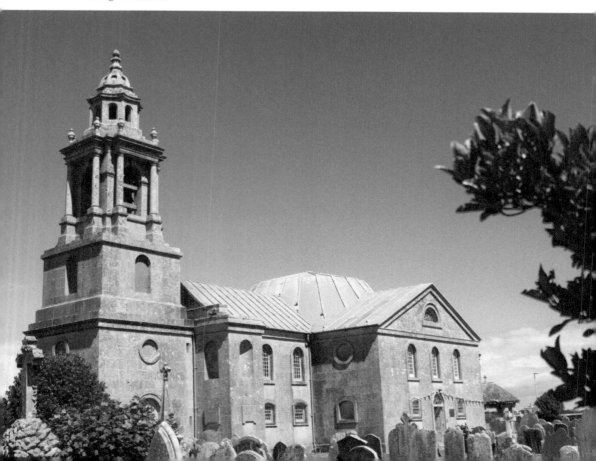

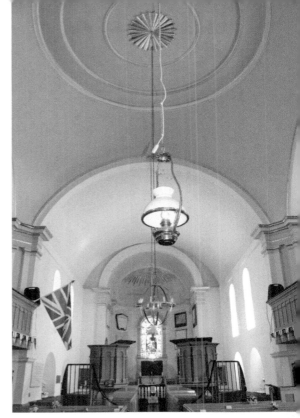

Inside St George's Church.

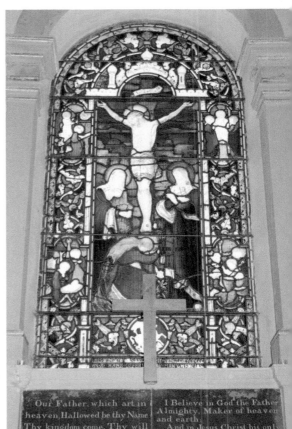

St George's stained-glass window above the altar.

Pevsner describes it as 'the finest Georgian church in Dorset'. The Royal Commission on Historical Monuments is less flattering.

I think that Gilbert was trying to bring some of the grandeur he had seen at St Paul's back home to Portland. The tower is not unlike the towers of St Paul's, albeit on a modest scale. St Paul's has a dome and so does St George's, which is an unusual feature on an English provincial church.

It is true that without an unaffordable outer tea-cosy dome the roof looks a bit as if it is topped by a squashed pork pie, but so would St Paul's if you took off its outer dome. Maybe Gilbert hoped that one day funding for the tea cosy to compliment the glorious inner saucer dome would come.

St George's lost its ecclesiastical function in 1917 and is now looked after by the Churches Conservation Trust.

13. Belfield House, 1780
Belfield Park Avenue, DT4 9RB

Belfield House is a jewel of a small country house built in extensive parkland between what is now Buxton Road and Wyke Road. Originally its grounds extended west to Wyke and east to Cross Road. It was designed by John Crunden for Isaac Buxton.

With two floors plus an attic and basement, it is built of stone and yellow brick in the classical style, with proportions that are as near perfect as could be. The entrance is approached by two flights of curved steps fronted by four Ionic columns. The hall leads on to an octagonal room beyond and a semicircular internal staircase mirroring the ones

Belfield House.

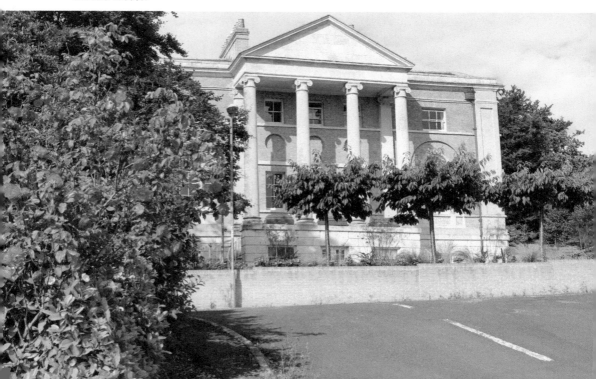

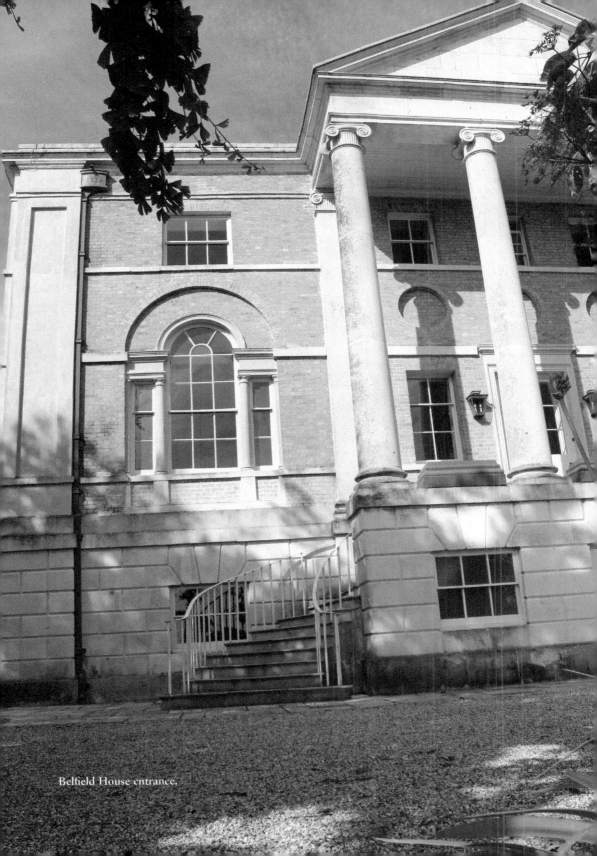

Belfield House entrance.

outside. To the left is the drawing room and to the right the dining room, both extending the full width of the building and illuminated in the front by large Venetian-style windows.

A regular visitor was Buxton's grandson, Thomas Fowell Buxton, who loved the house and the town, becoming one of Weymouth's MPs from 1818 until 1837.

Buxton was not a parliamentarian to tow the party line and, along with his sister-in-law Elizabeth Fry and others from a Quaker background, had strong views about political reform, particularly in areas such as the mistreatment of the poor and the cruelty of one human being to another as demonstrated through the prison system. He was opposed to capital punishment and saw the number of offences for which it was the penalty reduced from 200 to just eight in his life.

It is for his work for the anti-slavery movement that Buxton is best remembered. Taking forward the baton from William Wilberforce, who had achieved the abolition of the slave trade in 1807, Buxton's lobbying ensured that slavery itself was abolished in the British Empire from 1833.

There is a memorial to him in Victoria Gardens next to the Houses of Parliament and he features as one of a group on the back of the Elizabeth Fry five-pound note. He is the man on the left with glasses.

14. Gloucester Lodge, 1780
Esplanade, DT4 7AT

George III's younger brother, the Duke of Gloucester, took such a fancy to Weymouth that he built his own holiday home, Gloucester Lodge, just outside the town overlooking the beach and with a garden extending south through what are now Royal Terrace and Frederick Place. Built of red brick, it originally had just two storeys plus cellars with two Venetian-style windows for the ground-floor principal rooms.

The 1780s were difficult for George III. America had become uppity and cast itself adrift from England, provoking a war which England lost. This affected the king badly. He became ill and one solution was to take a dose of the health-giving properties of Weymouth. Accompanied by Queen Charlotte and three of their children, the king arrived at Gloucester Lodge in June 1789 and stayed until the middle of September.

The daily routine included bathing in the sea, excursions along the coast in one of the naval ships, horse riding, visits to attractions like Sandsfoot Castle and calls upon local dignitaries with music, dancing and gossip in the evenings.

It was a great boost for Weymouth to play host to the monarch. The king was welcomed, although there was some irritation that he started off by having his own groceries sent down from London rather than buying the local produce at regally inflated prices.

George enjoyed the visit so much that he returned every summer (bar two) up to 1805, by which time his health was in decline and he was under treatment from Dr Simons of St Luke's Hospital for Lunatics. He was the man who invented the straightjacket and almost certainly did poor King George more harm than good.

On the king's death, Gloucester Lodge was sold and its royal contents put up for auction. In 1860, a large extension to the south was added for the exclusive Dorset Club with the whole lot eventually becoming a hotel. After a serious fire in 1927, an additional storey was added. Today, Gloucester Lodge is divided into apartments with a bar in the basement.

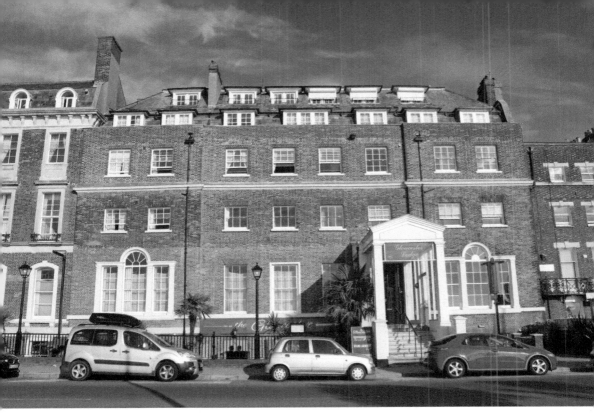

Above: Gloucester Lodge, holiday home to the Duke of Gloucester and George III.

Below: Gloucester Lodge extension for the County Club.

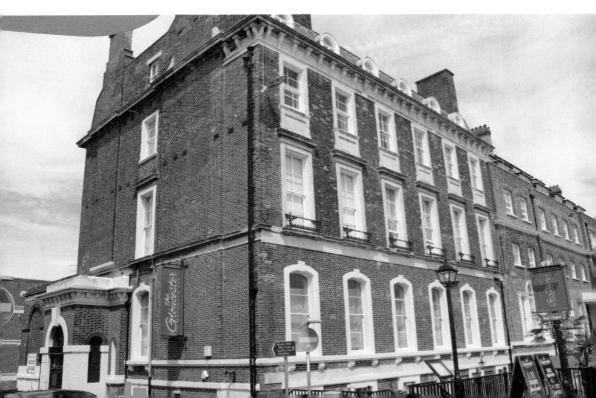

15. Harvey's Assembly Rooms, 1791
No. 51 Esplanade, DT4 8DQ

John Harvey was a local entrepreneur, visionary and engineer who was at the heart of the development of the town as a suitable resort for George III and his social set. He even proposed building a breakwater at Portland half a century before pressing military concerns turned it into a reality.

In 1791, he built his library, card and assembly rooms on the Esplanade to which anyone who was anyone came during their Weymouth visit to mix, mingle and chat. It is a distinguished building fronted by a row of Ionic columns.

Harvey also produced a map of Weymouth for the in-crowd on which he was careful to exclude all of his competitors such as Stacie's Hotel in Gloucester Place, which had its own assembly rooms and was definitely there, but of which there is no sign on Harvey's map.

In 1875, the library became the clubhouse for the Royal Dorset Yacht Club and continued to attract a royal clientele. The future Edward VII was commodore from 1897 to 1902. George V became patron and flew the club's burgee when sailing, which was later presented to the club by Edward VIII and Queen Mary. The Duke of Edinburgh became patron in 1952.

Weymouth was also a calling point for the luxury yachts of the rich, many of whom visited the club, including Sir Thomas Lipton – as in Lipton's Tea – and G. A. Henty who died aboard his yacht at Weymouth in 1902. Henty made a fortune with his adventure stories in which his brave and quintessentially British heroes were good and all the rest of

Harvey's Library, now a nightclub.

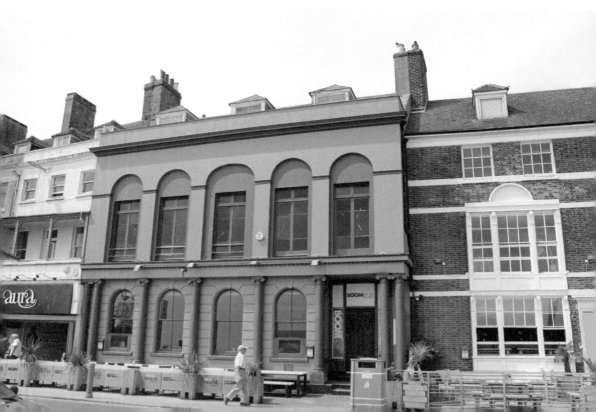

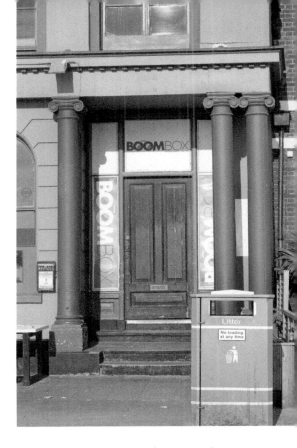

Harvey's front door.

the world was bad, being awash with dangerous foreigners, spies, natives and savages who needed to be bossed about or, if resisting, imprisoned, shot or blown up.

The RDYC moved into different premises on Custom House Quay in 1975 and today Harvey's once sedate and genteel library is painted matt black and functions as a nightclub called the BoomBox, in which revellers can pound to the beat while knocking back the Jägerbombs.

16. Eliot's Bank, 1792
Nos 62–63, St Thomas Street, DT4 8EQ

Today, we think of banks as huge national or multinational corporations. In earlier times, most towns had their own local institutions for looking after their money and Weymouth was no exception. As the local economy boomed with aristocratic wealth, William Eliot set up a bank in his own name in Weymouth in 1792.

In the 1820s, a new counting house of yellow brick was built at No. 63 St Thomas Street with a central doorway, grand hall and a spiral staircase with stone treads, iron balusters and mahogany handrails.

In 1840, Eliot took his nephew Edward Pearce into the partnership and under them the bank expanded, taking over No. 62 St Thomas Street and opening branches in Portland, Dorchester and Bournemouth. This pair died in 1885 and the business continued under the management of their sons, Richard Eliot, George Eliot and Sir Robert Pearce-Edgcumbe.

Nos 62–64 St Thomas Street.

The bank was highly respected and counted among its many customers the council, local gas and water companies, the county court and HM Customs. Richard Eliot was a JP and chairman of the Local Board of Guardians. George Eliot was also a JP, had twice been mayor and was chairman of the engineering and paddle steamer operating firm Cosens. Sir Robert had been a Dorset County Councillor and mayor of Dorchester.

It therefore came as a seismic shock for the town to discover on the morning of 31 March 1897 that the bank had gone bust, taking with it the life savings of many local people.

Subsequent enquires revealed that poor investments in the previous decade had gone spectacularly wrong, making the bank insolvent. There had been some warning signs for those with eyes. None of the partners had any capital in the bank and Sir Robert had tried to buy himself out of the partnership in 1896.

The main bank office survives at No. 62 St Thomas Street and now has a café and bar on the ground floor. The counting house at Nos 63 and 64 was knocked down in 1966 to make way for Tesco's first Weymouth store.

17. Lodmoor Barracks, 1797
Alexandra Road, DT4 7QQ

Protecting George III during his holidays in Weymouth required troops. Troops required barracks and these were located on the Nothe, in the centre of town near what is now Debenhams and by the main road in and out at Lodmoor Hill.

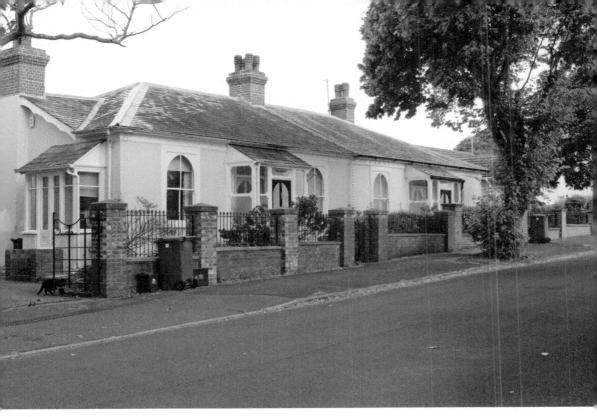

Barracks for the German officers.

Lodmoor Barracks was built around 1797, with additions in 1800 and 1804 for the cavalry and extended over a large area between the Dorchester Road and what was then the Backwater. At its peak, it housed 953 officers and men and 986 horses.

The need for more troops to protect the king grew as the political situation in Europe deteriorated. In July 1789, during the king's first Weymouth visit, French revolutionaries stormed the Bastille in Paris. In 1793, they guillotined their king, Louis VI. This was followed by a bloodbath of other French aristocrats and the threat to topple all Europe's monarchs.

Was our king safe? Would they kill him? With France only 60 miles away across the Channel it would have been a huge embarrassment if crack French revolutionary agents had landed on Weymouth beach and spirited our king away to have his head chopped off by the Paris mob.

Continuing his advance, in 1803 Napoleon's army seized the Electorate of Hanover. This was a real blow for the king: his family came from Hanover – his German-speaking great-grandfather, who became George I, and his grandfather, George II, were both born there.

Refugees fled from Napoleon's advance with some coming to England. A number of these expatriate Germans, many from Hanover, were recruited to fight alongside the British Army in a special regiment called the King's Own Legion. They were billeted in Lodmoor Barracks from 1804 until 1816.

All that remains today of these extensive barracks, which finally closed in 1828, are the bungalows by Lodmoor bus stop and Nos 24 and 26 Alexandra Road. They have rendered timber-framed walls with Gothic-style windows and were used to house the German officers in this German regiment fighting for the Hanoverian George III for Britain.

18. Pennsylvania Castle, 1800
Wakeham, DT5 1HZ

Pennsylvania Castle was built around 1800 as a Gothic Revival country house to a design by James Wyatt for John Penn on land gifted to him by George III who, with his wife Queen Charlotte, became regular guests on their Weymouth visits.

Penn was the grandson of William Penn, founder of Pennsylvania in America, and had substantial property ownership there until the war with Britain in which the New World sacked the old, declaring independence.

Back in Britain from 1789, Penn received a considerable pension from the government and spent his time and wealth in a dilatory way writing poems and plays and involving himself with other projects as the whim took him. Although he never married, Penn founded the Outinian Society in 1817 with a mission to encourage harmony among those who had.

Perhaps Penn's greatest whim was building Pennsylvania Castle, which is not a castle at all but a fairy-tale mansion set in idyllic surroundings. It is built of ashlar Portland stone and squared rubble with rectangular towers at each corner and a large circular tower to the north-east, all topped with embattled parapets that give the whole thing a fantasy castle-like appearance.

The house remained in private ownership down the subsequent years, welcoming many distinguished guests along the way including Sir Winston Churchill, General Eisenhower and General de Gaulle in the run-up to the D-Day landings. After the war it became a hotel.

Pennsylvania Castle.

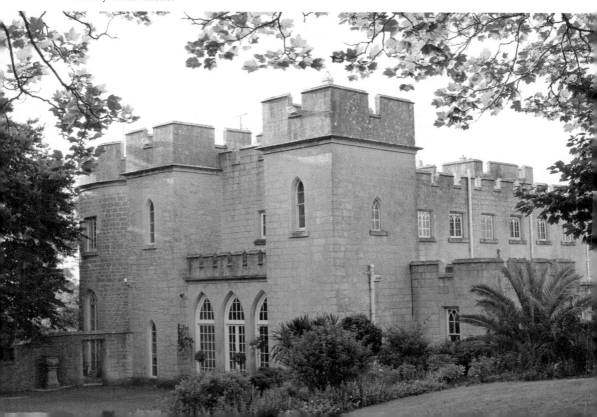

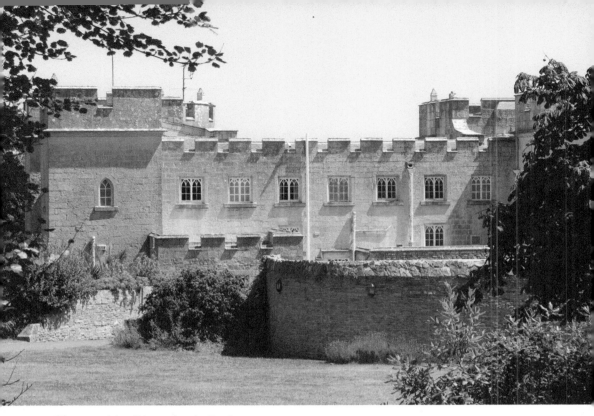

The west side of Pennsylvania Castle.

As a place, it has such atmosphere. Sitting there on the hotel terrace years ago on a summer evening, with a glass in hand and a friend by my side, each soaking up the view of cliffs and sea beyond, made my younger self feel as if I had entered into a richer life than before – well, for a few moments anyway.

In 2011, Pennsylvania Castle had an internal makeover and now functions as an exclusive luxury venue that can be hired for private events. It has attracted a rich clientele including Hollywood stars and TV personalities. Given his known tastes, I think John Penn would have liked that.

19. Cove Cottages, 1808
Cove Row/Cove Street, DT4 8TT

In 1781, a decision was taken to improve the look of the harbour by filling the inlet around the cove, which then extended up to where Brewer's Quay is today. Work progressed and, by the turn of the century plans were developing to build six cottages facing the harbour in Cove Row and a further five around the corner in Cove Street on this newly reclaimed land.

With an eye on making sure that any new buildings looked good and did not detract from the image the town was projecting to the wider world, these cottages had to be built to a specification defined by the council. This stipulated that 'they shall be entered by two steps of usual depth, shall be 16 feet high to the roof from the bottom of the ground floor and be 24 feet deep and so as to range in a straight line and to be uniform'.

Above: Cove Street cottages.

Below: Cove Row cottages with the *Roebuck* moored outside.

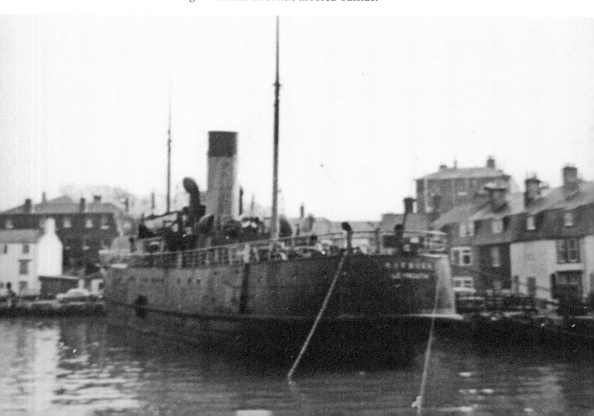

Building commenced in 1808 and the result is a group of charming brick cottages with two storeys and attics under slate-covered mansard roofs. The front doors are under arched heads and, as built, each floor had one square sash window to the front. Less picky planning committees in later years allowed the addition of bay windows to three of them.

One long-term resident of Cove Row was Capt. Jimmy Goodchild who joined the Great Western Railway Channel Island ships in the 1930s as second mate. Promoted master of the cargo ships *Roebuck* and *Sambur* in 1946 and the passenger ships *St Helier*, *St Julien* and *St Patrick* in 1953, he became the last captain of the *St Julien* when she was withdrawn in September 1960 and retired in 1962.

The view from Cove Row onto the harbour was obstructed each year from September through to April by the Channel Island boats, which laid up there for their winter refits towering over the adjacent cottages. The huge steel rings for their mooring ropes are still embedded in the surrounding roadway today.

20. King's Statue, 1809
Esplanade, DT4 7AN

George III left Weymouth for the last time on 4 October 1805, a couple of weeks before Nelson scored his spectacular success against the French fleet at Trafalgar. The king's health continued to deteriorate and, in 1811, his son George was appointed regent. Thereafter he became a virtual recluse until his death in 1820.

The king's statue.

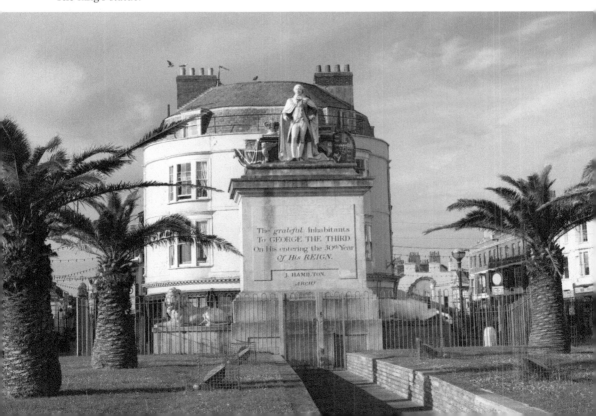

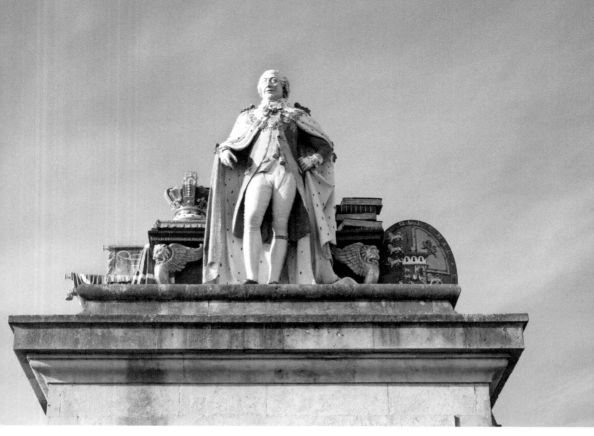

King George III with all his kit.

The king's visits most summers over sixteen years boosted Weymouth as a resort hugely. In the cult of the celebrity at the time, a place the king endorsed by his presence was a place to which those who could afford it wanted to come.

After he stopped coming, locals wondered if his visits might be forgotten and a steady stream of tourists lost. In order to combat this, a statue designed by James Hamilton was commissioned. If the king couldn't be there in person, he would be ever-present in stone as a permanent reminder of the royal connection and thereby helping to keep the cash registers jingling.

Sited at the north end of St Mary and St Thomas Streets, the king's statue was unveiled in 1809. It has a large podium with moulded plinth and cornice in Portland stone with the sculptures on it in Coade's artificial stone. The king is portrayed standing in Garter robes holding his sceptre next to a table supporting his crown and books, flanked by the union flag and the royal arms. On a lower level there is a unicorn and a lion couchant. On the front is an inscription stating that the statue was from 'the grateful inhabitants to George III in entering the fiftieth year of his reign' and on the back a list of sponsors.

Since then there have been two campaigns to remove it. In the 1880s, a group lobbied for its destruction claiming it to be 'un-slightly, hideous and a mass of pottery', and in 1938 lobbyists argued that it obstructed the view of motorists.

Fortunately it survived these attempts and, with the tableau painted in vivid colours since 1949, it remains a memorial to the man who made Weymouth a fashionable resort.

21. Devonshire and Pulteney Buildings, 1812
Esplanade, DT4 8EA

Dukes, duchesses, viscounts and other aristocrats with names like Devonshire, Johnstone and Pulteney came with their extended families to Weymouth for holidays through the Bath connection forged by Ralph Allen. Some, together with their relatives, stayed longer than others, leaving a greater mark upon the town; for example, General Sir James Pulteney, whose wife Henrietta was Countess of Bath, was one of Weymouth's MPs from 1790 until his death in 1811.

The two adjacent terraces at the southern end of the Esplanade, Devonshire and Pulteney Buildings were erected between 1805 and 1812. They have three storeys, a cellar, an attic under a mansard-slated roof, bow windows on two floors and a moulded cornice and parapet. All except one are single-fronted.

In 1819, the council, then mindful of the aesthetic elegance of the town, insisted that the flat end of Devonshire Buildings should be rebuilt bowed to produce a better effect.

One distinguished resident of Devonshire Buildings in the middle of the nineteenth century was Joseph Drew, owner of the *Southern Times*. His combination of energy, skills and hard work seems to have been formidable. In addition to his newspaper business, he owned the Victoria Hotel and, in 1852, entered into partnership with his neighbour in Pulteney Buildings, Capt. Joseph Cosens, to build the paddle steamer *Prince*. On Capt. Cosens's death in 1876, he became chairman.

Devonshire Buildings.

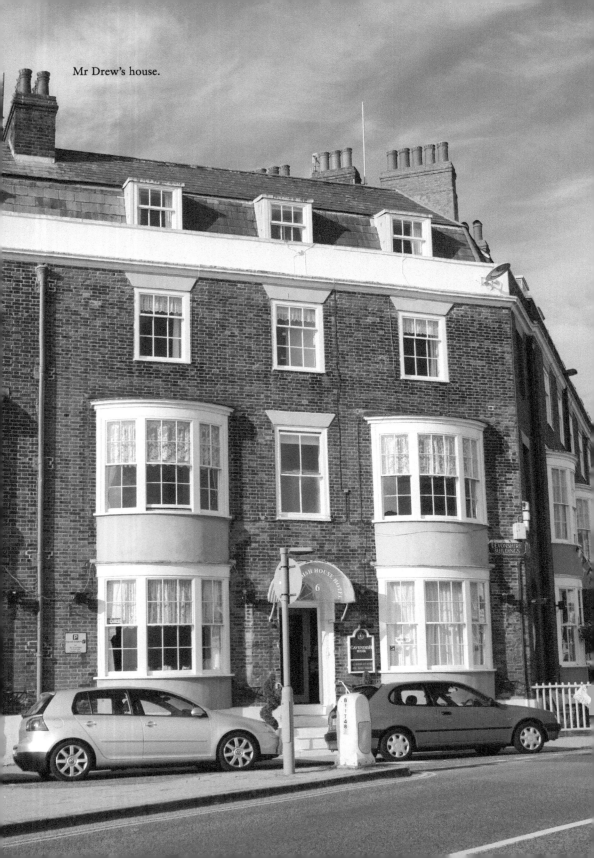

Mr Drew's house.

Drew also patented three inventions: a method for cutting lozenges; biscuits with a motto on them like 'Will you marry me'; and an improvement for the protection of ship's hulls against projectiles. In his spare time, he wrote extensively including a romantic novel *The Poisoned Cup* set around Sandsfoot Castle in the late sixteenth century. He also collected paintings including those by Poussin. A Fellow of the Royal Society of Arts, he was awarded an honorary doctorate from Richmond University in America in 1874.

Today these two elegant terraces remain as built and are small hotels.

22. St Mary's Church, 1817
No. 43 St Mary Street, DT4 8PU

The mother church of the parish at Radipole, St Ann's, built a chapel of ease in St Mary Street, Weymouth in 1605. By the beginning of the nineteenth century this had become too small to accommodate the growing population and the moneyed tourists then flocking to the town. A competition was therefore announced in the *Salisbury Journal* on 5 December 1814 to design a new and larger church to be built on the same site.

This was won by local architect James Hamilton. Work commenced the following year and the new St Mary's opened its doors for worship in 1817. It is a fine building with ashlar walls of Portland stone and a slate roof topped by a cupola containing a clock with a wrought-iron weathervane on top of the dome. The church is of rectangular shape with three doors with fanlights set between six Romano-Doric pilasters leading out onto St Mary Street.

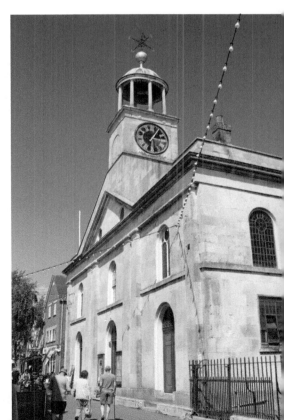

St Mary's Church on St Mary Street.

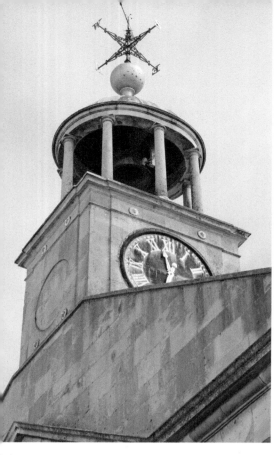

Left: St Mary's cupola.

Below: James Thornhill's *Last Supper* over the altar.

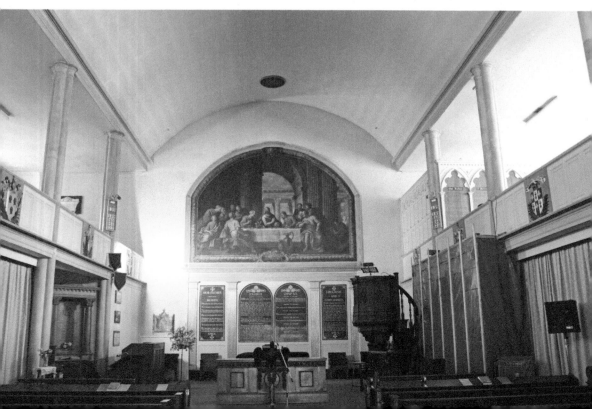

Inside, there is a panelled gallery on three sides with four sets of stairs, one in each corner of the church, leading up to it. Over the altar, there is a picture of the last supper painted by local boy made good, Sir James Thornhill.

Fine as it is, the architecture has had its detractors, with the 1970 Royal Commission on Historical Monuments being particularly sniffy. They reported that 'the building is of particular interest as an expression of the empiricism of a provincial architect acquainted with, but possessing little knowledge of, the neo-Classical style of the period'. Ouch!

For around half a century, from 1961, the church enjoyed the services of one organist, John Wycliffe-Jones. Educated at Queen's College Cambridge and at the Guildhall School of Music in London where he studied the organ under the Master of the Choristers at St Paul's Cathedral and conducting under Sir Adrian Boult, Wycliffe-Jones brought music to Weymouth not only in the church but also as conductor of Weymouth Choral and Operatic Societies.

23. Brunswick Terrace, 1827
DT4 7RW

Brunswick Terrace was built between 1823 and 1827 with an official naming ceremony by the Duke of Gloucester, then calling it Brunswick Row, taking place on 16 August 1824 before most of it had been put up and only three months before the great storm that caused such devastation along the Dorset Coast.

Brunswick Terrace.

They are all of basically the same design: bow windows on two floors, two rooms on the ground and first floors with dividing doors between them and two more bedrooms above with further attic accommodation above that. Unlike similar properties in Waterloo Place, there are no basements, which reflects the fact that digging down to provide rooms that would have been below sea-level at high tide so close to the beach is not prudent if you value dry feet.

The south end of the block is bowed, reflecting the pair of buildings at the north end of St Mary Street. The middle two project slightly and are higher than the others, giving the whole block a nice symmetry.

As a boy, the author John Cowper Powys and his brothers stayed with their grandmother in Brunswick Terrace and this gave them a lifelong love of the town. John seems to have had some eccentric habits including tapping his head on letter boxes after posting his missives for luck and eating a diet which consisted largely of eggs, bread and milk topped up with occasional treats like guava jelly. We know all this, including his sexual preferences, because he describes it all in some (perhaps too much?) detail in his autobiography.

His novel *Weymouth Sands*, written while homesick in America and published in 1934, gives fascinating insights into the geography of the town a hundred years ago and combines the mystical with the earthy. It is populated by a cast of colourful characters including a sinister clown, a Punch & Judy man, a libidinous town clerk, an exploitative quarry owner, lesbian lovers, an asylum and an odd-job man fixated on a young beauty he meets disembarking from the Channel Island mailboat.

Typical Brunswick Terrace house.

24. Holy Trinity Church, 1829
Fleet Road, Fleet, DT3 4EB

From the beginning of the nineteenth century to the First World War, no less than thirty-four new churches and chapels were built in Weymouth to accommodate the growing population as the town expanded. Holy Trinity Church, in the nearby village of Fleet, was built between 1827 and 1829 for a different reason.

Looking out today from what remains of the old church onto the placid Fleet lagoon, with Chesil Beach protecting it from storms sweeping up the English Channel, it is almost inconceivable to imagine what happened on the night of 22/23 November 1824 when winds, likened by a local naval officer to a West Indian hurricane, combined with a huge storm surge to devastate the Dorset coast.

At Weymouth, the sea level rose above the harbour walls carrying boats into the nearby streets. The north end of the Esplanade was breached by the massive waves at a position near to the future Prince Regent Hotel connecting the sea to the Backwater and so cutting off the town.

At Fleet, before fleeing for their lives, local residents saw a tidal wave burst through Chesil Beach, thunder across the lagoon and tear up the valley to the village 'at the speed of horses', before carrying away cottages and most of the old church. By the following morning, many buildings in South Dorset had had their chimneys or roofs removed. Others had been completely demolished. Ships had been wrecked. Dozens were left dead. It was a dreadful night and a weather event way beyond anything that has happened since.

Holy Trinity Church, Fleet.

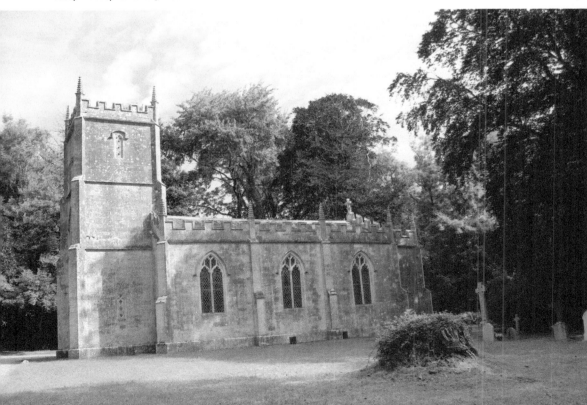

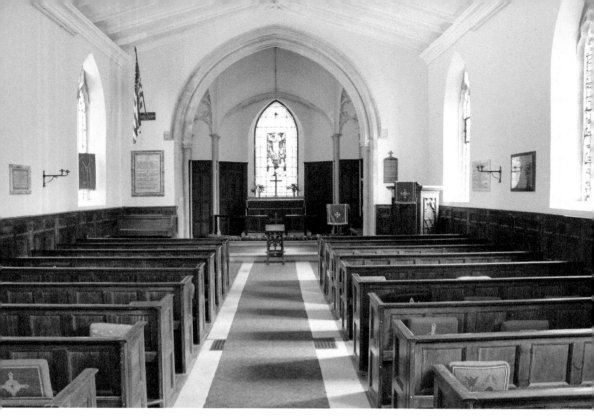

Inside Holy Trinity Church, Fleet.

After that, plans were made for a replacement church to be built further inland with finance for it provided by Revd George Gould, one of Weymouth's wealthiest residents, who lived at nearby Fleet House, now the Moonfleet Hotel.

The result, Holy Trinity, is in the Gothic Revival style with ashlar stone walls and an interior containing many fine architectural details. The stained-glass window over the altar features the Resurrection of Christ and contains some of the glass saved from the old church.

25. Octagonal Spa House, 1830
Nottington Lane, DT3 4BJ

If you were suffering from 'cramps, rickets, gun-shot wounds, fistulas and other depressing ailments' as described by Dr Pickford and fancied the healing remedy of sulphurous water, which, according to Commin's Directory, 'had the smell of scouring guns, and the taste of a very hard-boiled egg', then the place to be was the Octagonal Spa House just outside Weymouth in Nottington where you could bathe in, and imbibe, the purifying benefits of the waters of the River Wey.

Nottington water had already been bottled and sold from about 1822 and it was Thomas Shore, a local corn merchant with a mill at Nottington, who saw a gap in the market and engaged Robert Vining to build the Octagonal House as a spa.

It is a curious building with its eight sides, three floors and a basement, which contains the pump for bringing the therapeutic water from the adjacent River Wey into the house.

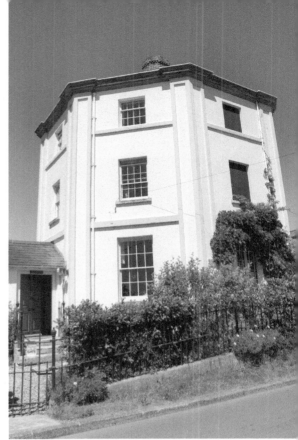

Right: Octagonal Spa House.

Below: Cottages next to the Octagonal House.

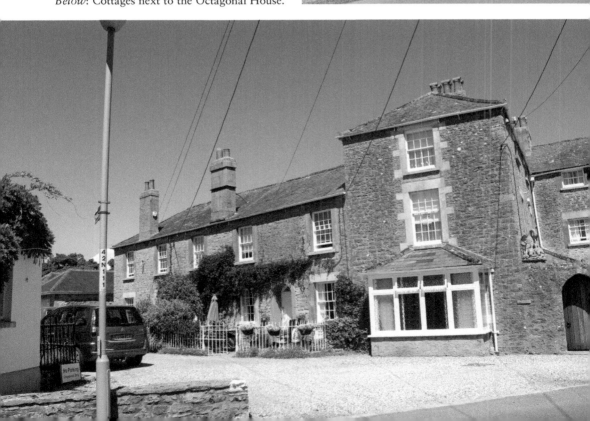

As built, each floor was divided by a wall extending north–south through the house with the fireplaces in the middle leading up to a chimney stack at the centre of a slate roof. The outside walls are of brick, rendered with stucco, and have panelled pilasters at the corners and a moulded cornice on top.

The distance from Weymouth was said to have made 'a delightful morning's ride' with the premises open from 6 a.m. to 8 p.m. For those less mobile, and for invalids, overnight accommodation was provided in the cottages next door.

The Nottington spa was a great success but it was not without local competition. A rival was set up on the lands of Radipole Manor, in what is now Spa Road, with a Gothic-style pump room and bathing house set among bucolic trees.

Business declined as the century moved on and by 1900 Radipole Spa had gone and been replaced by houses and the Octagonal House had become a private dwelling.

Today, drinking all that ghastly water seems mad, but when you see how green, tall and thriving the vegetation grows by the Octagonal House it makes you wonder.

26. Workhouse, 1836
Wyke Road, DT4 8RF

The end of the Napoleonic wars, with the Battle of Waterloo in 1815, led to around 200,000 former troops and sailors flooding the civilian labour market in which there was insufficient work for all. On top of that, the Corn Law was passed the same year, increasing the price of bread and leading to riots and dissent. All of this put a severe strain on the many charitable organisations that had hitherto provided some relief for the poor around

Weymouth Workhouse.

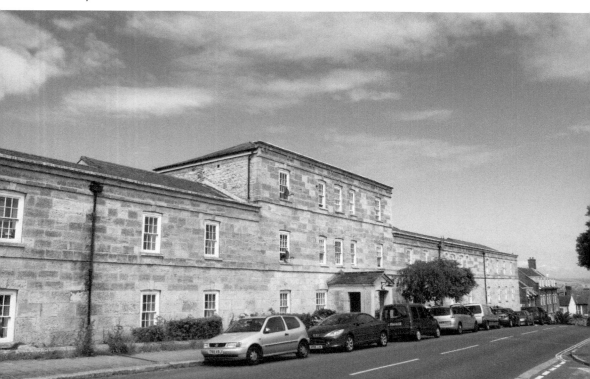

The Workhouse front door.

the country. In due course this led to the Poor Law Amendment Act, which was introduced in 1834 to save money and standardise the way benefits were given by building workhouses to accommodate the needy.

Charles Dickens satirised these institutions in *Oliver Twist*, in which the young and near-starving inmate Oliver asks the bloated, overweight and well-fed beadle Mr Bumble for 'some more, please, sir'. The beadle's refusal to stick his ladle back into his vat of gruel to serve up seconds plays badly with our sympathies but he was just doing what the law required. The dial of delivery in the workhouse was permanently set on low, with a harsh regime and survival-level rations to keep out all but the most destitute and needy.

The Weymouth Workhouse was built in Wyke Road with Portland stone ashlar to the front and rubble to the back. It had separate wards for men and women around four internal courtyards with the master's house in the middle. A room was set aside for use as a school for girls in the west corner at the front, with another for the boys at the east end.

This rigorous regime continued throughout the nineteenth century and on until 1929 when a more benign government abolished workhouses ninety years after Dickens had flagged up their deficiencies.

The Weymouth Workhouse, rebranded as Portwey, became a hospital for unmarried mothers, the sick and the elderly. After the Second World War, it reopened as Weymouth's Maternity Hospital. This closed in 1987 and the building is now divided into flats.

27. Portland Prison, 1848
Grove Road, DT5 1DL

Prior to the nineteenth century, gaols were relatively few in number and generally intended to house small numbers of inmates for fairly short periods prior to other punishments like being hanged or transported to the colonies.

As crime grew in Victorian Britain, with large populations centred in cities, prison became a place for longer sentences with the intention of deterring, punishing and reforming criminals. Between 1842 and 1877, no less than ninety new prisons were built across the country to satisfy the growing demand.

The regimes were harsh and brutal; for example, a conviction for tampering with the signature on a will led to a period of solitary confinement in prison followed by hard labour on the treadmill or stone smashing before transportation to Australia.

It did not take the commercial thinkers in government long to notice that the hard-labour part of a sentence might be put to better use in providing cheap labour for public building works, for which no wages had to be paid and for which rations could be minimal and of the poorest quality – a sort of slave labour really.

One such project followed from the decision to build breakwaters at Portland. Accordingly, a new prison was commissioned to be built on Portland to provide the men to do it.

Much of the prison, including the cell blocks, was rebuilt in the early twentieth century but the gatehouse was made of coarse rubble, with its vermiculated quoins and a simple moulded cornice topped by the royal arms, dates from 1848. The nearby cottages in Alma Terrace

Portland Prison, now in use for young offenders.

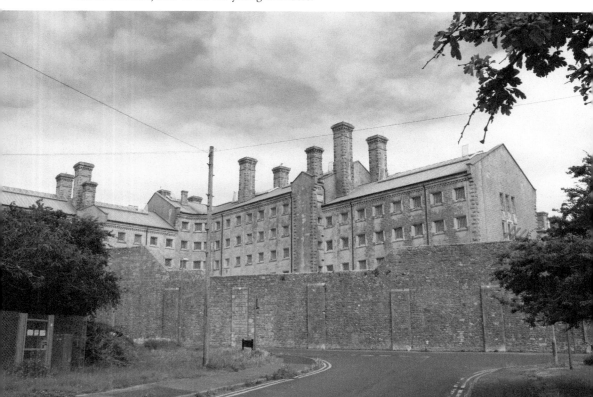

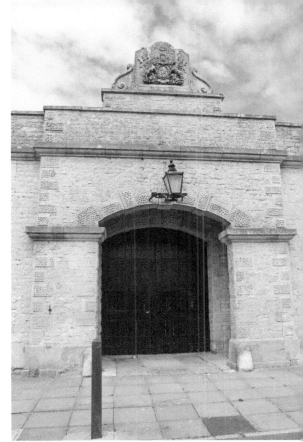

Right: Prison gatehouse.

Below: Prison church of St Peter.

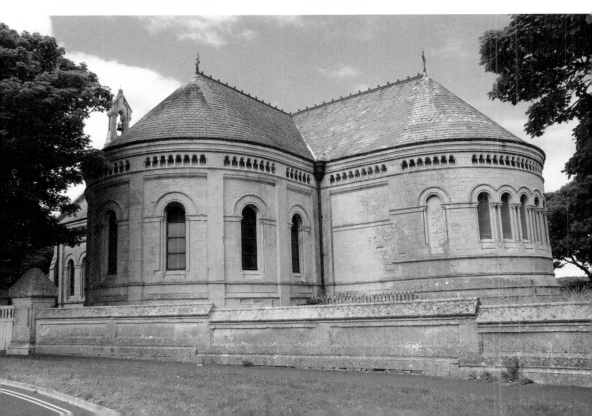

were built for prison warders and are from around 1850. The assistant governor's house, school and St Peter's Church, which is in the Romanesque style, were built around 1870.

The first sixty-four convicts arrived at Castletown by sea from Portsmouth in November 1848 and started work in the quarry next to the prison immediately. In 1921, the building was converted into a Borstal for particularly difficult boys and it is still in use today for young offenders.

28. Portland Breakwaters, 1849
Portland Harbour, DT5 1PP

As the empire expanded, there was a need for more warships to police the trade routes. This, coupled with the requirement for coaling stations to fuel the new steamships that were replacing sail, meant that more bases were needed for ships back home.

The Commission of Enquiry into Harbours of Refuge, set up in 1844, identified Portland Roads, which had long provided shelter for ships from Channel gales, as a suitable location. As a result, the foundation stone for the first of two breakwaters, to be built out from Portland, was laid by Queen Victoria's consort, Prince Albert, in July 1849.

The work was supervised by James Rendell, who had been a surveyor for Thomas Telford, with John Coode as the Engineer in Chief from 1856. Manual labour was provided by convicts from the freshly built Portland Prison.

The technique was to build a substantial wooden pier with up to six railway lines on it along which trucks could travel to deposit their loads of rubble, quarried in Portland,

First two breakwaters built out from Portland.

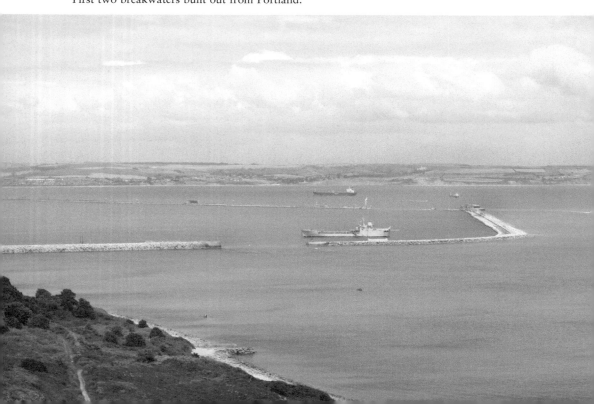

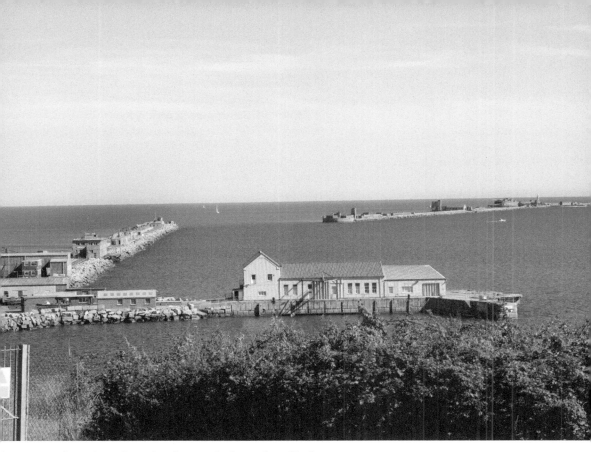

Above: Second two breakwaters built out from Bincleaves.

Below: Pier built to take rubble out for the first two breakwaters.

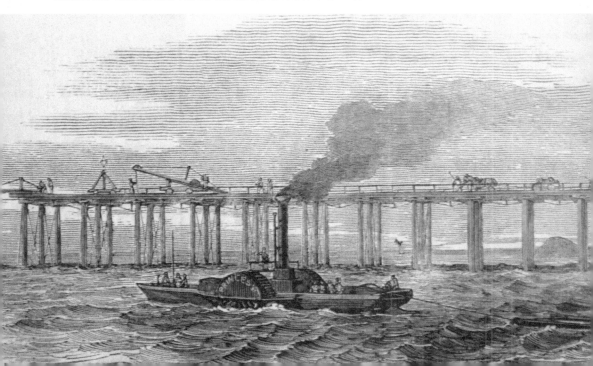

directly into the sea. The logistics were hard. There was a need for 2,000 tons of stone every day. The water is around 20 metres deep and the whole project was subject to disruption and damage by gales, particularly from the south-east. It was not until August 1872 that the Prince of Wales laid the last stone and declared the breakwaters complete.

In 1885, Russia invaded Afghanistan and, although war with Britain was averted by diplomacy, it was a scare. The French set up torpedo boat stations along their coast around the same time. These two developments troubled the admiralty and led to a decision to build two more breakwaters extending out from Bincleaves to enclose the harbour fully.

This second stage was undertaken by private contractors, W. Hill & Co. Instead of building a wooden pier first, the rubble was shipped from Portland in barges and tipped straight in. Work commenced in 1893 and was finished by 1906, taking just thirteen years to complete compared with the twenty-three years for the first two.

29. Weymouth Railway Station, 1857
King Street, DT4 7BJ

One thing missing from Weymouth was a park with drives, paths, walks, trees and flowers. There was no land available for such a luxury so, in 1834, a decision was taken to make some by filling in parts of the Backwater to the west of the Esplanade.

Although the land was reclaimed, the park never materialised following various financial and other difficulties. Instead, part of it was sold on to build the railway station for the Great Western and South Western Railways, which jointly opened up a service to Weymouth in 1857.

Railway station built on land reclaimed from the Backwater.

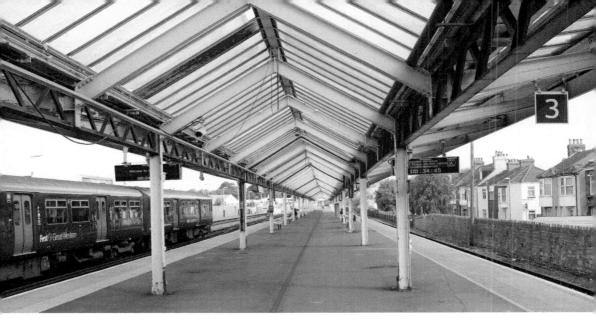

Today's platform with the Park District houses on the right.

The reclaimed land beyond that was bought by the Conservative Land Society, which marketed plots to build new houses in what is now known as the Park District.

It was the arrival of the railway that transformed Weymouth from a resort for the moneyed elite into a mass-market holiday destination for everyone. People who had never had the opportunity to travel long distances before suddenly could with fares that were affordable for all. It became as easy for a factory worker and his family from Birmingham to reach the resort as a duke and duchess from Bath. Weymouth's holiday profile was about to change.

30. Nothe Fort, 1860
Barrack Road, DT4 8UF

Henry John Temple, 3rd Viscount Palmerston, served in government for forty-six years. He became prime minister five years after work building the Portland Breakwaters had started and died in office, aged eighty-one, in 1865.

Palmerston is remembered for many things but his name today is most often attached to a series of ninety forts he commissioned to protect naval dockyards and other areas of strategic importance from the Thames to Pembroke against a perceived threat from the French under Napoleon III. They cost a fortune to build and they saw no action in Victorian times. They are now most often referred to as 'Palmerston's Follies' and the Nothe Fort is one of them.

A contractor started building a suitable sea wall on the Nothe for the new fort in 1860 but, after difficulties, was replaced by the Royal Engineers. The fort is shaped like a half-moon with a flat side to the west. The walls are of coarse ashlar, with the seaward-facing stones being particularly large and almost a metre thick. There are three levels with the magazine at the bottom over which is the gun deck and accommodation for the troops with ramparts and a raised platform above that. It was finally commissioned in 1872, the same year that the first two Portland Harbour Breakwaters were completed.

Left: Nothe Fort.

Below: Inside Nothe Fort.

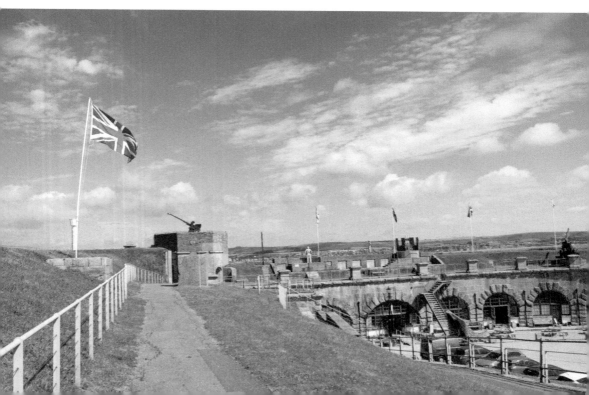

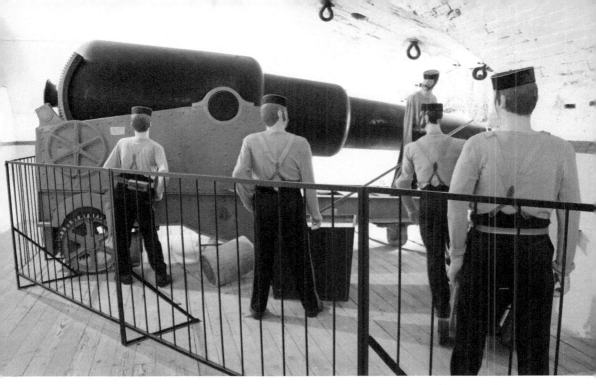

Muzzle-loaded cannons inside Nothe Fort.

As built, 18-ton muzzle-loaded cannons were fitted but with developments in weaponry they were superseded in the 1890s by much bigger 38-ton versions with a range of 3.5 miles. In due course, further developments replaced them with breach-loading guns capable of firing shells up to 10 miles. They were so enormous that the building required structural work to take their weight.

Having never previously had to fire a shot in anger, action was seen in the Second World War, particularly in providing anti-aircraft fire during German bombing raids on Weymouth and Portland Harbour.

Decommissioned in 1956, the Nothe Fort is now owned by Weymouth Civic Society and is open to the public. It is well worth a visit and is a good example of one of 'Palmerston's Folly'.

31. Thomas Hardy's Lodging, 1863
No. 3 Wooperton Street, DT4 7DX

Wooperton Street was built in 1863 as part of the development of terraced cottages, constructed between the backs of the grand houses on the Esplanade and the Backwater. They were built with three floors, had four bedrooms and looked onto a large pond on the site of the present car park, which was used for seasoning timber. The owners of No. 3 took in lodgers and one of these was the twenty-five-year-old Thomas Hardy who stayed there on and off between 1869 and 1871.

Born near Dorchester, Hardy had known Weymouth, which he called Budmouth in his writings, all his life. His mother had been in service in the town as a girl. As a seaside resort, he knew that it buzzed with the frisson of worldly excitements, ever-filling the minds of the

Above: Hardy's lodging second from the left in the white terrace.

Left: Wooperton Street looking towards the Backwater.

young and not so young. In his later poem *Budmouth Dears* Hardy put into the mouth of a hussar thoughts that must surely have come from the longings of his own younger self: 'When you lay where Budmouth beach is, all the girls are fresh as peaches.'

Having trained as an architect, Hardy had spent the previous five years in London working as part of the project to build the railway station on the site of the old St Pancras Church. It was a difficult job involving the removal of graveyards and their contents but it had given Hardy the opportunity to meet new people and further his own education by visiting galleries and museums as well as going to the theatre and opera.

He had also written his first novel, *The Poor Man and the Lady*, but was depressed to find that it had been rejected by several publishers.

Picking himself up from this setback, Hardy took advice, moved back to Dorset and, while working in Weymouth for local architect Crickmay, penned much of his second novel *Desperate Remedies* at No. 3 Wooperton Street. To his relief, this was accepted and this success set him off on the road to literary fame and fortune.

32. Working Men's Club, 1873
Mitchell Street, DT4 8BT

Based on the real-life W. H. Smith, Sir Joseph Porter in *HMS Pinafore* sings 'I grew so rich that I was sent by a Pocket Borough into Parliament. I never thought of thinking for myself at all but always voted at my party's call. I thought so little they rewarded me by making me the ruler of the Queen's Navy.'

Working Men's Club.

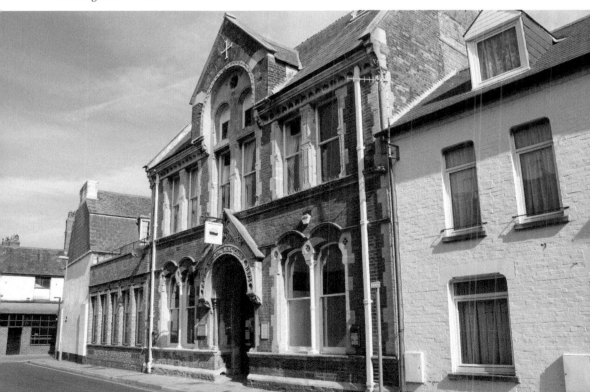

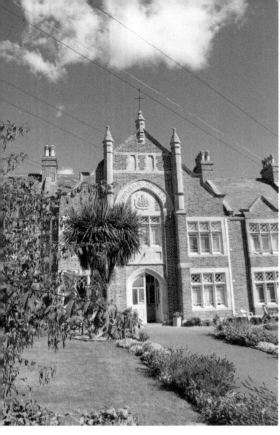

Edwards' Homes.

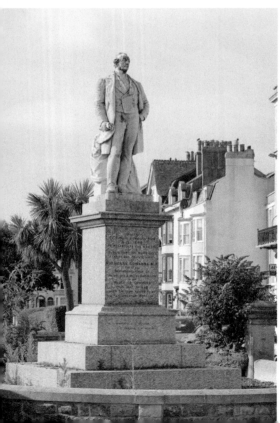

Statue to Sir Henry Edwards.

Weymouth was a pocket borough, sending four MPs to parliament at each election, despite its small size and even smaller electorate, until such things were abolished in 1885. Of course not all of these MPs were on the make like Sir Joseph Porter. There were exceptions including Thomas Buxton and Henry Edwards MP from 1860 to 1885.

With his own money, Edwards built the Weymouth Working Men's Club in 1873. He lobbied, albeit unsuccessfully, for the government to build the new Britannia Royal Naval College at Portland, arguing that Dartmouth had a less wholesome atmosphere for cadets with their raw sewage emptying into the river. After retiring, he built the almshouses for Weymouth's poor in Rodwell Avenue and on Boot Hill. There is a statue to this good man on the Esplanade.

33. Cosens & Co., 1876
No. 10 Custom House Quay, DT4 8BG

Cosens was incorporated in 1876 with their head office in the building sandwiched between a mid-nineteenth-century warehouse, once owned by John Deheer and now Sharkeys, and the seaman's bethel, built in 1866 and now the Royal Dorset Yacht Club. It has a stucco façade and dentil cornice with a hoist to the second floor and an arch at street level in which steamer notices were displayed.

Cosens ran a fleet of excursion paddle steamers along the Dorset, Hampshire and Devon coasts and had several salvage tugs. They bought other local engineering firms and built extensive workshop facilities in Commercial Road. A major employer, their 1923

Custom House Quay.

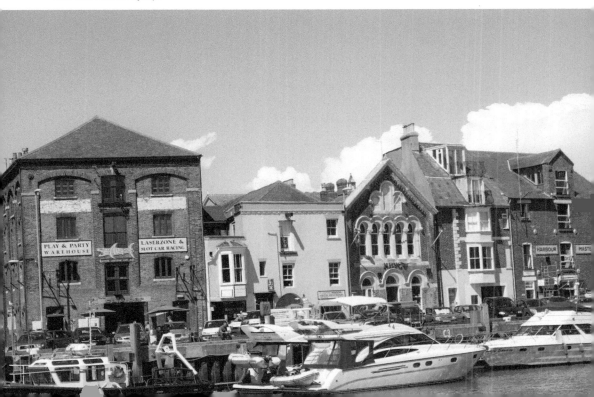

Cosens's former head office.

guidebook boasted that 'the youth of Weymouth will remember Cosens as a stepping stone into the engineering world'.

They also imported Norwegian block ice, built their own refrigeration plant and brought electricity to Weymouth years before the borough's own power station appeared at Westham in 1904 with their generator lighting not only their own works but also providing 'similar lighting for many of the principal businesses in the town'.

As their markets declined, Cosens sold this office in 1962, eventually moving what was left of their operations to Portland. The business closed in 1999.

34. No. 77 St Mary Street, 1884
DT4 5PJ

Looking above the shopfronts in St Mary Street today shows a combination of some old bow windows topped with mansard roofs remaining much as they were in Georgian times together with others having Victorian and Edwardian accretions extending upwards. No. 77 is currently occupied by F. Hinds, a family-run chain of jewellers. In the 1880s, it was the Weymouth office of a company renting out a revolutionary new product.

Alexander Graham Bell was born in Edinburgh in 1847 into a family interested in the mechanics of speech. While in America, in 1875, he made a receiver using electricity, which he patented as the telephone. Although this patent was controversial with others, including

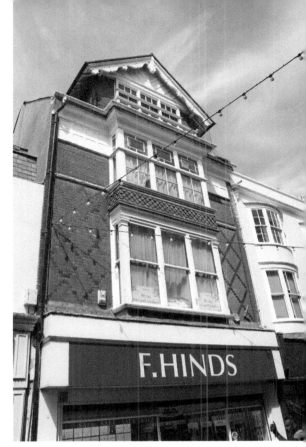

Right: No. 77 St Mary Street.

Below: Inside the exchange.

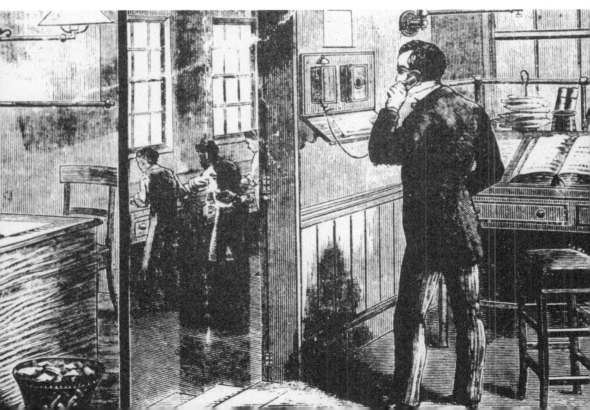

the Italian-American Antonio Meucci, claiming to have come up with the same idea, Bell got there first and became rich on the proceeds.

In Britain, a number of companies sprang up with licences from HM Postmaster General and the United Telephone Company to bring Bell's patented telephone to the provinces with the Western Counties and South Wales Telephone Company being incorporated in 1884. Its head office was in Bristol with a branch at No. 77 St Mary Street, Weymouth.

The company's local advertising boasted 'perfect simplicity of working with no training required; easy recognition of the voice of the speaker; immediate verbal intercommunication; and freedom of liability after payment of rent'.

The headline connection charge was £12 (around £1,340 today) per annum plus a weekly subscription of 4s 7d (around £25 today) although this applied only if you lived within 1 mile of the telephone exchange.

Getting connected involved rigging overhead wires between poles so the further away you lived, the greater the cost was of installing it with an extra £5 (£560 today) charged for each extra mile. That meant that if you lived in Pennsylvania Castle, about eight miles from town, the connection charge would have been £52 (around £5,800 today) per annum plus the weekly subscription. Cheap it wasn't.

From this shop, Weymouth started speaking to the world by telephone.

35. Whitehead's Factory, 1891
Whitehead Drive, DT4 9XT

Although underwater weapons, including mines, had been used before, it was Robert Whitehead and his Austrian partner, Capt. Luppis, who developed the moving torpedo, which could travel through water like a fish, sneak up unseen on a target and, to quote their own publicity, 'when in contact with the object it explodes and destruction is complete all round'.

Having already started to manufacture torpedoes in Italy, Whitehead eventually persuaded the admiralty to use them and, in 1891, set up a factory on an 8-acre site at Ferrybridge. It was an ideal location next to Portland Harbour that was suitable for testing; it was on the railway line between Weymouth and Portland so that a spur could be built to bring in raw materials and take away the finished products; and there was an expanding workforce available in Weymouth and Portland.

In order to house workers next to the factory, Whitehead built three rows of typical Victorian terraced cottages arranged with their backs facing each other around a triangular communal area. More red brick and slightly larger houses went up in the ensuing decade in Williams Avenue, Fairview, Parkmead, Sunnyside, Victoria and Gallwey Roads, the latter being named after Capt. Gallwey, the first manager of the factory. A school, two Methodist chapels and the Wyke Hotel followed. It was the arrival of Whitehead's factory that transformed the shape of Wyke Regis.

A pier with its own narrow-gauge railway carried the torpedoes out into the harbour for testing. Firing stations were set up on the new breakwater at Bincleaves and torpedo nets to catch them became a constant feature in the harbour.

Whitehead, his son John, his son-in-law Count George Hoyos and Capt. Gallwey all died in a short period between 1902 and 1906 and the works passed to a partnership between Vickers and Armstrong Whitworth in 1907.

Above: Terraced cottages built for Whitehead's workforce.

Below: New houses built on the site of Whitehead's factory.

Metal girder and concrete posts from Whitehead's old torpedo pier.

Testing its last torpedo in 1966, the factory survived in various incarnations until 1998 when it was demolished to make way for houses. The original cottages, the factory's foundation stone and a tiny bit of the pier are all that remain today.

36. Abbott's Court, 1895
Ullswater Crescent, DT3 5HE

As work proceeded apace completing the terraced houses of the Park district north of the railway station, eyes were cast across the Backwater for other development opportunities in Westham, which had been linked to Weymouth by a bridge for the first time in 1859.

Builder John Bagg obtained leases for much of this land from the Earl of Ilchester and, from around 1880, set about building houses himself and subletting leases to others to build yet more first along Abbotsbury Road and then branching off on either side. In the spirit of keeping costs down, particularly in Stavordale Road, some were built with bricks taken from the first Royal Hotel on the Esplanade that was pulled down in 1891.

As a result of this endeavour, Bagg became a dominant figure on the local council and was elected mayor between 1900 and 1902. He became sufficiently wealthy to build a substantial mansion in extensive grounds for himself at the north end of Radipole Lake. This he called Abbott's Court.

Unfortunately Bagg's taste for the good life, coupled with a decline in the building market as Westham filled up with new houses, led him into financial difficulties and he was declared bankrupt in 1910, losing everything.

Right: New flats in the grounds of Abbott's Court.

Below: The gateposts are all that remains of the old Abbott's Court.

Although Bagg was well known locally, Abbott's Court, was bought by a man with an international reputation. In 1888, Thomas Burberry patented gabardine, a particularly waterproof fabric, and by cleverly associating his products with use in extreme conditions, including the Antarctic expeditions of Amundsen and Shakleton and the pioneer flights of aviator Claude Graham-White, made his fortune with his name becoming synonymous with quality clothing. A 1908 advertisement for one of his suits claimed that it has 'practical impermeability to wet, cold winds and fish hooks'.

In later years, Abbott's Court fell on hard times and ended up being divided into small flats and bedsits before being demolished in 1987 to make way for the purpose-built apartments that stand on the site today. They retain the name, gateposts and view of their illustrious predecessor.

37. Royal Hotel, 1897
Esplanade, DT4 7AX

The present Royal Hotel was built on the site of a previous hotel of the same name that opened its doors in 1772. At first called Stacie's, this was the first large hotel in Weymouth purpose built for the new market segment of aristocratic tourists then flocking to the newly fashionable resort.

At that time, the hotel was just outside the town with no other buildings to the north of it along the Esplanade. It advertised an assembly room with bathing opposite and that a

Royal Hotel. *Inset*: Royal Hotel turret room.

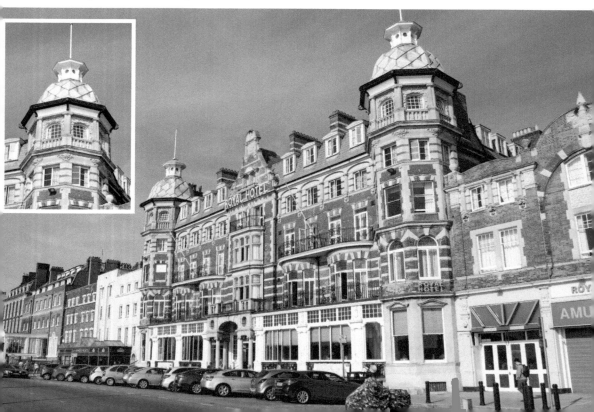

'well-appointed coach leaves the hotel daily'. By 1890, the old Royal had become too small for the greatly expanded holiday market and so was pulled down.

An unsightly gap in the Esplanade remained for several years until the new hotel was built. This is a sugar-plum-pudding of a building, with turret rooms on each end topped by domes with flagpoles. It just oozes a sense of late Victorian opulence announcing itself to the world as Weymouth's grandest hotel.

The entrance, which is flanked by four Ionic columns, leads into a large foyer with more decorative and partly fluted columns. There is a large dining room on one side and a bar on the other. Upstairs, the sea-facing bedrooms of varying sizes have stunning views out across the beach and bay. As built, it was the Weymouth hotel to which anyone with money and a sense of their own importance automatically gravitated.

The Royal remained open during both world wars and continued to attract a moneyed clientele. Sir Winston Churchill's wife Clementine stayed for a short break in the spring of 1943 and noted, in a letter, the anti-invasion tangle of barbed wire and iron barricades on the beach opposite and that the hotel was then reduced to serving Bird's instant custard with all its puddings.

Like many similar seaside hotels in the same class, the Royal was on the skids by the 1980s and became somewhat faded. Today, its fortunes have been revived by Shearings for use as one of their coach and holiday destinations.

38. Brewery, 1904
Hope Square, DT4 8TR

There has been a brewery on this site since 1252 with beer being seen as a safer and healthier drink than water in earlier times. It was owned by the Flew family in 1742 and was bought by William Devenish in 1824.

In 1904, John Grove built this new brewery next to that of his competitor Devenish. The front is in north German Renaissance style of red brick with a ground-level blue-brick frieze. There are four floors in the centre, surmounted by a tower with a roof lantern, cascading down to two floors on either side. The multi-paned windows are separated by large brick pilasters. Round the back there is a vast warehouse and a boiler room with a tall chimney to provide steam for the brewery engines.

It is the biggest building in Weymouth and screams out the heavy demand for beer in the town in the Edwardian era. Of course, not all of it was drunk by locals. By 1904, Weymouth was a mass-market holiday resort, with every hotel, boarding house and pub filled to capacity in the peak weeks and thirsty holidaymakers escaping their routine lives for all the fun and excitement of the seaside.

In addition, when the fleet was in, as it often was, thousands of sailors flooded the town on their runs ashore with two things uppermost in their minds. One of these was booze.

Ferrying them to and fro was one of the duties of Cosens's paddle steamers and it was not easy work. A press report speaks of difficulties on the *Premier*, with her engineer quoted as saying 'the captain blew down the voice-pipe to tell me to ignore the telegraph as it had been taken over by drunken sailors'. On such nights, hundreds of other matelots, unable to find a bed ashore or too drunk to walk back to the pier, slept off the booze on the beach.

Groves amalgamated with Devenish in 1960 with the business moving to Cornwall in the 1980s. Today Brewer's Quay combines eateries and an antiques market.

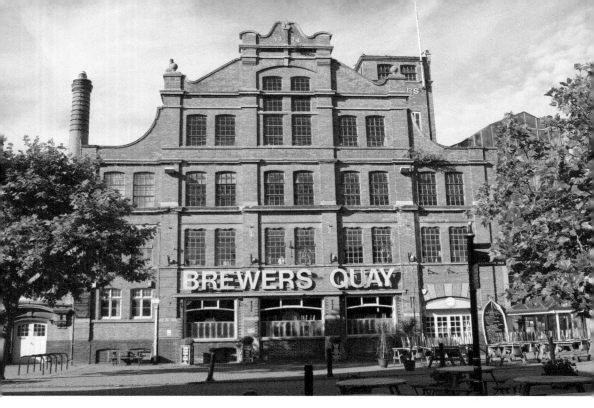

Above: John Grove's brewery.

Left: The brewery chimney.

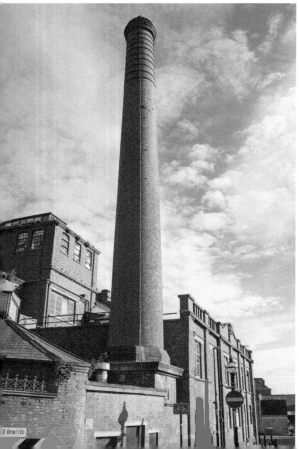

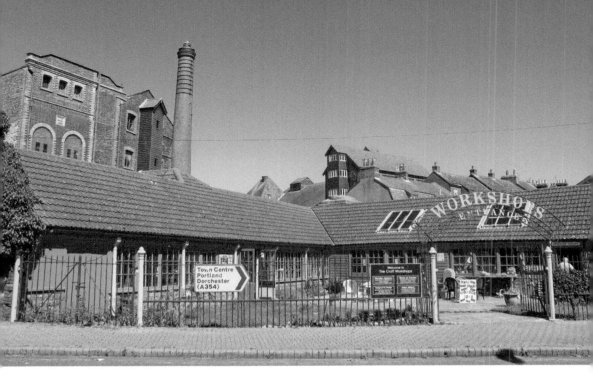

Brewery blacksmith's buildings.

39. Portland Bill Lighthouse, 1906
DT5 4JT

Before satellite navigation and radar could define the position of a ship day or night whatever the weather, mariners were dependent on taking visual sights of objects in the heavens, on land or at sea in order to ascertain where they were.

If it was cloudy, if the visibility was poor or if the weather was bad, preventing captains from taking such bearings, then they extrapolated from their last known position where they thought they might be, taking into account their speed, course and their predictions of how they thought the effects of the wind and tide might set them. If these calculations were only a degree or so out, and if the poor weather extended over several days, their actual position could end up being miles out from where they thought they were.

Given that Portland sticks out into the English Channel, it is not surprising that, in poor weather or at night, ships of all sizes, including ocean liners, sometimes crashed into Chesil Beach, the rocky coast of Portland or the treacherous Shambles Bank, which extends just below the surface, 4 miles east of the Bill.

In order to help mariners avoid these deadly dangers, a private consortium took a lease from Trinity House in 1716 to build two lighthouses on Portland, so positioned that when in line, as viewed from the sea, they marked the western end of the Shambles Bank.

They were replaced in 1869 by two new lighthouses, which remain in private ownership today. These were thought to be situated too far away from the Bill after the paddle steamer *Bournemouth* slammed into the west side of Portland while returning from a daytrip to Torquay in thick fog in 1886.

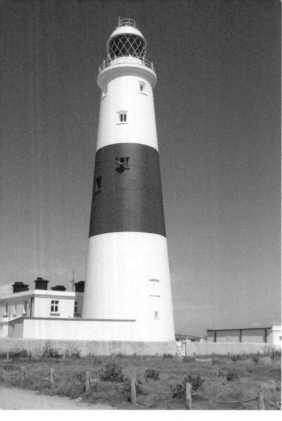

1906 Portland lighthouse.

Old 1869 lower lighthouse.

The present lighthouse was therefore built closer to the Bill in 1906. It shines out a white light, flashing in groups of four every twenty seconds visible up to 25 miles and a fixed red arc extending over the Shambles Bank. There is also a loud foghorn blasting out its presence every thirty seconds when the visibility is poor.

40. Pavilion Theatre, 1908
Esplanade, DT4 8ED

As Weymouth filled up as a major seaside resort for the masses, the need for new theatres to entertain them became pressing. In 1887, the Jubilee Hall, which could seat around 1,300, had been built behind St Thomas Street but even that was not big enough. Plans were therefore drawn up for another theatre to be constructed on reclaimed land at the end of the Esplanade next to the harbour.

The resulting Pavilion was built largely of wood and designed in the mould of many other seaside theatres going up at the time. There were towers topped by domes on each corner at the front. A veranda on three sides offered the opportunity to admire the views. Inside the auditorium there were stalls and a circle, together with boxes complete with crimson drapes. Much use was made of cream, gold and pink paint to create an opulent atmosphere.

The theatre opened in 1908 to much acclaim and survived, latterly under the name Ritz, until 1954 when it caught fire and was utterly destroyed. The decline in holiday trade, which came in the 1960s and 1970s, was still some way ahead and in the 1950s Weymouth was still heaving with visitors. This gave confidence to build a replacement theatre on the same site.

Ritz *(left)* with the Channel Island mailboat *St Helier.*

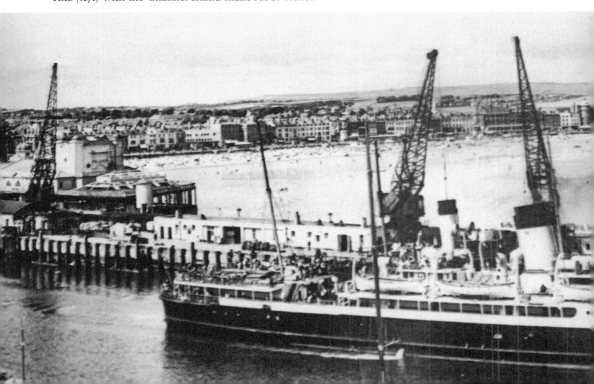

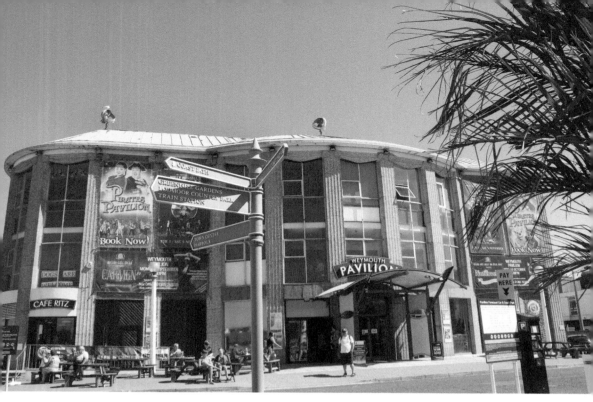

1960 Weymouth Pavilion.

Designed by Samuel Beverley, the new Pavilion, which also contains a dance hall, opened its doors in July 1960 with a show starring Benny Hill. This started a pattern that continued with an annual summer show and Christmas pantomime laden with stars from the London stage and television plus other entertainments in between. The Bournemouth Symphony Orchestra also brought their music and some of the world's most international conductors and soloists including the legendary Constantin Silvestri, Antal Dorati and Ida Haendel.

Despite the Pavilion's long-term success, various plans were developed around 2006, one of which was to demolish it and put up luxury flats, a hotel and the inevitable shopping mall instead. Fortunately this came to nothing and the theatre is now open again under the management of a not-for-profit Community Interest Company.

41. Westham Council Houses, 1920s
DT4 0LJ

One of the problems at the end of wars is what to do with the returning troops, many of whom will be injured, if not physically then mentally, by what they have seen happen and done themselves. It was an issue at the end of the Napoleonic Wars. It was an even greater issue at the end of the First World War given the scale of that conflict and the enormous numbers involved.

The First World War had also seen a proletarian revolution sweep away the Russian tsar and his ruling elite. People started to wonder why it had happened at all given that the heads of state of the countries at the heart of the conflict, King George V of Britain,

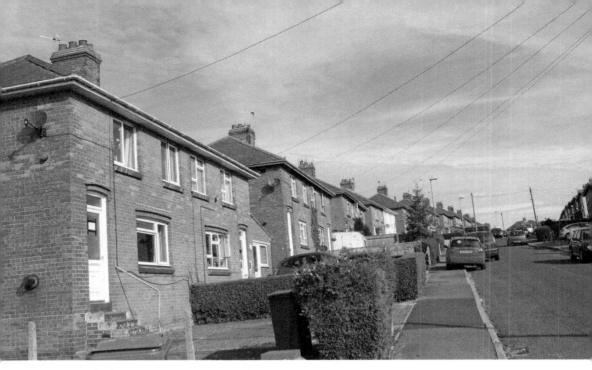

Homes for heroes.

Kaisser Wilhelm II of Germany and Tsar Nicholas II of Russia, were all first cousins who shared the same grandmother, Queen Victoria.

It was felt that things could not go on like this and that ordinary British people needed better treatment. As a result, the 1919 'Addison Act' made housing a national responsibility and placed a duty on local councils to build houses and rented accommodation for working people as 'homes fit for heroes'.

Following this, a new housing estate was built on the edge of Westham on land which had only recently served as one of Weymouth's several camps for injured Australian troops.

Looking at the houses today, they may not look particularly special but they were a huge step up from the tightly packed Victorian and Edwardian terraces, built by the likes of Mr Bagg, which preceded them. They have a bigger footprint, they are semi-detached and they all have a little bit of garden in which to grow flowers and vegetables. Although it takes some imagination to see it, they were also designed to look like small Georgian town houses.

As a gesture towards the tens of thousands of Australian troops who had passed through Weymouth in the war, the new streets on which these houses were built were given names like Queensland Road, Adelaide Crescent and so on.

42. Westham Bridge, 1921
DT4 8N

Building 'homes fit for heroes' was one thing. Finding work for heroes was quite another. Before the First World War, Weymouth's economy had been buoyant. The military had been on an upward trajectory at the Portland Naval Base, at Whiteheads and elsewhere. Holidaymakers were in ready supply to boost the summer economy.

Westham dam with the trap for keeping out debris.

Plaque on Westham Bridge.

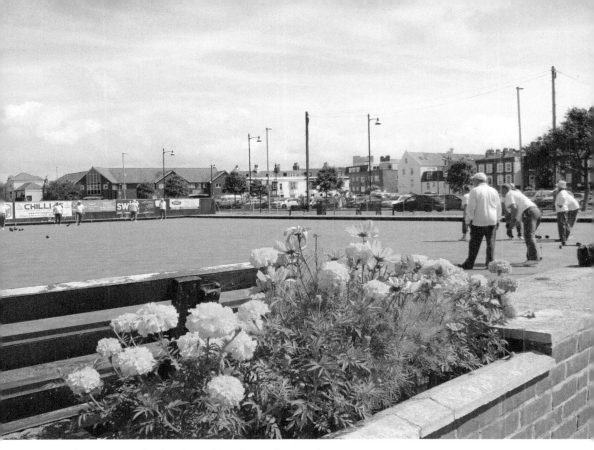

Bowling green on land reclaimed beside Westham Bridge.

After the war it was a different story. The military was contracting everywhere. The national economy was in a slump and Weymouth's holiday beds were not full. As a result, the council considered what public works might be done to provide jobs with schemes that might also boost the local economy.

The Backwater had ever been thought to be a problem as Weymouth's extended low tides meant that there were long periods when much of it was largely exposed mud. This had a tendency to provide its own distinctive odours and was a breeding ground for mosquitos. In order to try to keep some water in it at all states of the tide, a small dam had been built across the harbour at a position halfway between the end of Westham Road and Lower Bond Street in 1872, but the results were not great.

The proposal was therefore made to provide work by building a new and bigger dam to double as a bridge in place of the old 1859 Westham Bridge. Further associated reclamation work was planned to the west of Commercial Road to create a bowling green, tennis courts and gardens. By the 1930s, this extended even further north along the shore line towards Radipole, providing yet more tennis courts and gardens. On the western side of the harbour between Abbotsbury Road and Boot Hill, more reclamation continued and Westwey Road was created. A lot of rubble was chucked into Weymouth harbour in the 1920s and 1930s, extending the land mass of the town outwards.

The first phase, Westham Bridge, opened in 1921 and the previously tidal Backwater above it gradually acquired the rather grander soubriquet of Radipole Lake.

43. Wyke Regis Bridging Camp, 1928
Camp Road, DT4 9HH

One of the first things to happen in wars is that bridges get blown up. One of the first things that the Royal Engineers have to do is put them, or at least some similar structure, back up again. Sappers need to be trained for this, which requires a suitable training camp.

Prior to 1927, such a camp had existed at Mudeford but it was not perfect and kit had been lost in winter storms. In 1928, the camp was moved to Wyke Regis adjacent to the Fleet lagoon, which provides ideal circumstances for lessons. It is sufficiently wide but not too much so. It is tidal but the tides are gentle. It is fairly shallow, so if trainees fall in then it is no big deal and there is no regular boat traffic to get in the way. It is hard to think of a better location anywhere in the UK.

Since then, generations of Royal Engineers have learnt the skills of connecting pontoons, moving them about and bridging troubled waters to reconnect communications. These skills they have taken from Weymouth and carried round the world.

The lagoon also proved to be an excellent testing site for the bouncing bombs designed by Barnes Wallace, which were immortalised in the Second World War film *The Dambusters*. Such a bomb was thought by the brass hats to be impractical but the tests on the Fleet in February 1943 demonstrated that it could be done. This led to the raids on several dams in the Ruhr Valley in Germany that May.

These were counted a great success at the time as they breached the dams and disrupted the war effort in various factories. However, the raids remain controversial. The damage was repaired by the end of the summer and many civilians and prisoners of war had been

Wyke Regis Bridging Camp.

Fleet lagoon with Chesil Beach and Portland beyond.

swept away and drowned by the ensuing floods. In 1977, a revised protocol in the Geneva Convention banned such bombing if breaching dams would be likely to unleash forces leading to severe losses among the civilian population.

44. Old Castle Road Developments, 1930
DT4 8QE

In 1931, as part of their continuing public works, Weymouth Council laid out the land surrounding Sandsfoot Castle as 'Tudor Gardens' with colourful floral beds on the flat bit, which had previously been a tennis court. Builder Edwin Denton put up a teashop opposite to provide refreshments and set about constructing the semi-detached houses extending between the gardens and the beach. Behind the first four, he made a market garden to provide produce for his café, which he augmented with crabs caught in pots laid from his own boat in the reefs beyond the castle.

These semis are typical of those built with liberal use of pebble-dash all over the country in the 1920s and 1930s. They also provide an example of how a little bit of Weymouth went out into a wider world.

I grew up in No. 39 and my father, Winston Megoran, had a studio at the back of the house from which he drew and painted illustrations for a wide range of magazines including *Yachting Monthly, The Navy, The Sphere, Pictorial Education, Boy's Own Paper* and the *Eagle*, as well as providing book jackets for many London publishing houses. His watercolours, oil paintings, etchings and aquatints were sold through his agent in Birmingham nationwide and also overseas.

Above: Sandsfoot Tudor Gardens.

Below: Edwin Denton's developments.

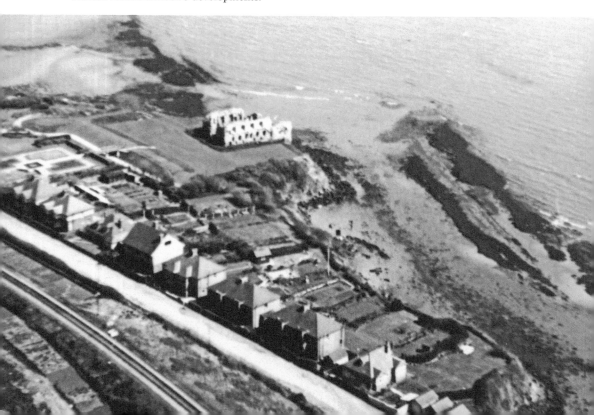

Cdr McHattie RNR was a Weymouth lad who went to sea as a boy, obtained a master's ticket and came ashore in the late 1930s to become one of P&O's choice pilots for their liners through the Suez Canal. This was a colonial lifestyle with the starched linen napkins for tea and a boy to carry the bags but it all came to a grinding halt in 1956 when Egypt's ruler, Colonel Nasser, nationalised the canal, chucked the British out and promoted the local tug skippers to become pilots instead.

McHattie, with his wife Betty, returned home and bought the semi at the other end from which their first view was of Portland Harbour filled with BP oil-tankers laid up as a result of the very same Suez crisis.

45. Pleasure Pier, 1933
Esplanade, DT4 8ED

Before the nineteenth century, the north harbour wall reached little further than the end of the promenade. An extension, ending in a pile pier, was built in 1859 and this gathered various modifications over the years.

With the arrival of the new Channel Island mail-boats *St Helier* and *St Julien* in 1925 plans were drawn up for a complete revamp of the area with new berths for them and a Pleasure Pier extending further out for Cosens's paddle steamers.

This opened in 1933 with local trips offered round Portland Harbour, to Lulworth Cove, Portland Bill and the Shambles Lightship and daytrips along the coast to Swanage, Bournemouth and the Isle of Wight or West Bay, Seaton and Torquay. In the evening, 'Grand Illumination Cruises' showed off 'Weymouth's Fairy-like Illuminations' from the sea.

Pleasure Pier with car park built over the original approach.

PS *Consul* alongside the Pleasure Pier.

After the last regular paddle steamer sailings by the *Princess Elizabeth* ended in 1965, local excursions continued with the *Weymouth Belle*, run by Colin Horne and Bob Wills, until 1974. After that, the fortunes of the Pleasure Pier declined, particularly after further reclamation turned the approach into a car park for the Channel Island and Cherbourg car-ferries.

46. Portland House, 1935
Belle Vue Road, DT4 8RZ

The television series *Dancing on the Edge* told the tale of a black jazz band at the centre of playboy parties in 1930s London where aristocrats mixed with commoners to drink, dance and indulge in other associated activities.

Geoffrey Bushby was a member of just such a real-life social set, which included the future king, Edward VIII, and his lover, American divorcée Mrs Wallis Simpson. Bushby had money and, in 1935, used some of it to build this stunning Art Deco, Spain-meets-Hollywood, fantasy-style weekend retreat.

Designed by Lord Gerald Wellesley and Trenwith Wills, the result is breathtaking. Approached by a path through flowerbeds and palm trees, the white-washed outside walls sitting under a Roman-style roof suggest that it is a large bungalow. However, the house is carefully crafted on a slope so that the front door opens onto a staircase with hand-painted tiles leading down to the lower floor.

Above: Approach to Portland House.

Below: Portland House drawing room.

Portland House master bedroom.

There is sleeping accommodation for twelve arranged on two floors in a combination of single and double bedrooms, some with inter-connecting doors, and served by bathrooms tiled in pink, blue, green and white. All the bedrooms lead out onto either the upper or lower terraces with views over Portland Harbour. On the lower floor there is the drawing room and dining room. In a wing on the side is the kitchen and accommodation for a live-in housekeeper. It is a design masterpiece.

Unfortunately Bushby died shortly after the house was built so his plans for a Hollywood-style swimming pool in the bowl of the garden never materialised and the weekend parties never came. Instead the property passed to his sister Dorothy, who had quieter tastes. She lived there until her death in 1983, sometimes inviting boy scouts to camp in her grounds, as things gradually deteriorated around her in the house.

Following a major refurbishment, which has recreated the splendour Bushby had envisaged, Portland House is now in the National Trust portfolio of holiday-lets enabling all who fancy a luxury break 1930s-style to fulfil their dreams.

47. Riviera Hotel, 1937
Bowleaze Cove, DT3 6PR

One of the difficulties of a seaside holiday was that many of the cheaper boarding houses loaded themselves with rules laying down what their guests 'shalt' and 'shalt not' do. Some

Above: Riviera Hotel overlooking Weymouth Bay.

Below: Undercover view for all.

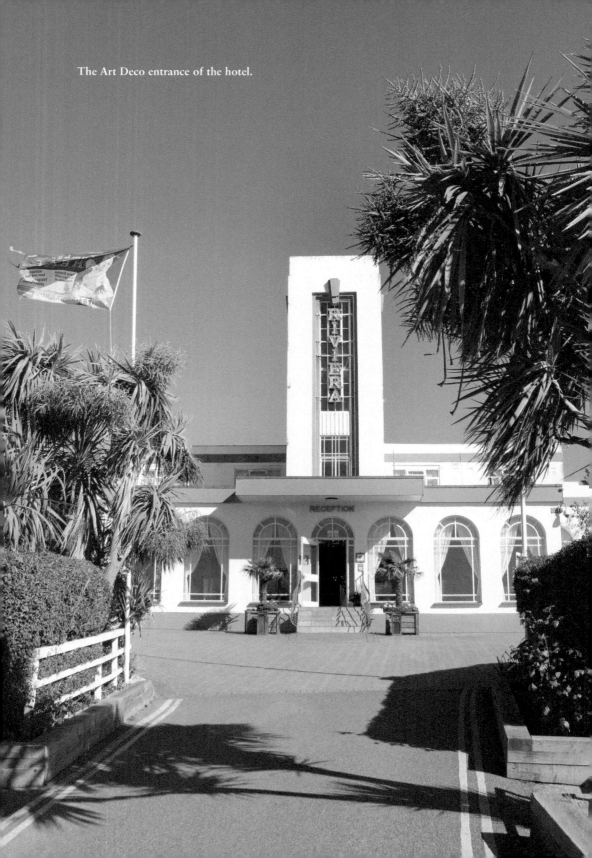

The Art Deco entrance of the hotel.

were quite restrictive and often imposed the requirement that everyone must go out after breakfast and not come back before supper come rain or shine.

A number of entrepreneurs, including Henry Warner, sought to address this issue by setting up holiday camps, which had a more welcoming attitude and something for guests to do all day. Others followed suit and by the Second World War there were around 200 holiday camps in Britain mostly in private ownership.

The Weymouth Riviera was built in 1937 in a perfect location overlooking Weymouth Bay and right next to its own beach. Constructed of reinforced concrete in the Art Deco modernist style, reminiscent of a large Spanish seaside villa, every bedroom looked out onto the bay and opened onto a covered walkway where guests could sit and admire the view whatever the weather. There was a swimming pool to one side and a ballroom round the back. It was just the sort of place where guests could dream that they were living the life that they saw the movie stars inhabit every week on the big screen at their local Gaumont cinemas up and down the land.

After the war, in which it was used by American troops in the run-up to D-Day, the Riviera was bought by Fred Pontin and became part of his holiday camp empire where 'blue coats' entertained the visitors and encouraged a good time to be had by all.

The development of cheap holiday packages overseas in the 1970s squeezed this market with the decline not helped by the image of the holiday camp being roundly mocked by the popular television comedy *Hi de Hi* with its loveable, but eccentric, cast of 'yellow coats' presided over by their semi-literate boss, Joe Maplin.

In 2009, the Riviera underwent a £4 million refurbishment and is now the Riviera Hotel.

48. Pier Bandstand, 1939
Esplanade, DT4 7RN

Unlike many resorts, Weymouth never had a proper seaside pier in the middle of the beach. However, in 1939 a sort of mini-pier was erected at the Greenhill end in the form of the Art Deco Pier Bandstand.

It didn't extend very far out to sea but had a grand entrance and a small open-air theatre in which bands could entertain the crowds. Not everyone approved with some thinking that it destroyed the grand sweep of the bay and that the open-air theatre was no good when it rained.

A regular feature there was wrestling, which had been popularised on Saturday-afternoon television in the 1960s and had a large following, not least among women. Famous names like Mick 'The Man You Love to Hate' McManus featured, usually pitted against some clean-cut godlike youth who became the butt of Mick's frequent fouls. However, things are not always what they seem. In his private life, McManus was an expert on Meissen porcelain and died in 2013 in the same nursing home as Sir Richard Attenborough.

The theatre part over the sea was demolished in 1986, leaving only the shoreward end with its restaurant and kiosks.

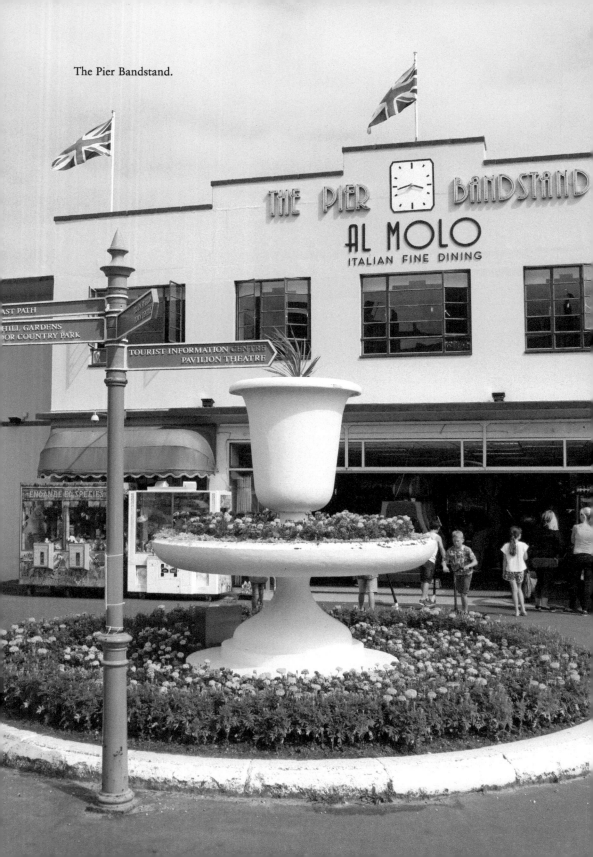

The Pier Bandstand.

The Pier Bandstand now without its theatre.

49. Admiralty Underwater Weapons Establishment, 1951
Southwell, DT5 2NA

Robert Whitehead's torpedoes could be launched underwater from an unseen vessel. Development therefore progressed to find ways to detect by sound what could not be seen by eye, and this resulted in ASDIC.

In 1951, the government set up the Admiralty Underwater Weapons Establishment on Portland to do further research, which led to ASDIC being renamed SONAR, much-improved detection techniques and intelligent torpedoes that could home in on their targets.

For testing the new kit, a former Mersey Ferry, *John F Farley*, and a one-time Clyde turbine excursion steamer, *Duchess of Argyll*, were bought, fitted with gantries on each side for lowering things into the water and moored in Portland Harbour. In 1969, they were replaced by a purpose-built floating structure called *Crystal*.

In the same year that AUWE opened, Enid Blyton, who regularly holidayed in Dorset, visited Portland. This gave her the idea for *The Rubadub Mystery*, a children's story about spies and nefarious goings-on at a secret submarine and torpedo research base. As events turned out, Enid proved to be particularly prescient.

In the atmosphere of the Cold War, all this top-secret military activity attracted the attention of the Soviet Union and, in 1961, the local community was rocked by the revelation that two employees at the AUWE, Henry Frederick Houghton and his girlfriend, Ethel Gee, had been arrested for espionage.

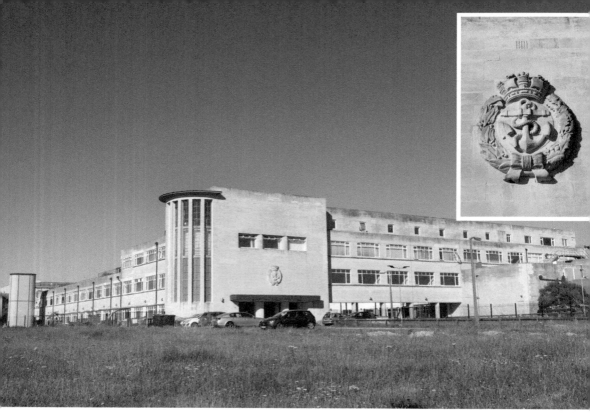

AUWE building. *Inset*: AUWE badge.

Neither seemed obvious spies. Houghton had a commendable service record in the Navy over twenty-two years before joining the Civil Service. Gee had come to work on Portland in her uncle's sweet shop before working at the AUWE as a clerical officer. The two became lovers and, for whatever reason, started to pass secrets to a Soviet agent, Gordon Lonsdale, in Ruislip. He was sentenced to twenty-five years, although he was swapped with Russia for British spy Greville Wynne in 1964. Houghton and Gee got fifteen years each, served nine and died in Poole in the mid-1980s.

The AUWE closed in 1995 and the building is now branded 'Southwell Business Park'.

5c. Weymouth and Portland National Sailing Academy, 2000
DT5 1SA

The same favourable tidal factors that attracted Ralph Allen, coupled with the building of the breakwaters, made Portland Harbour an ideal sailing venue.

Although it started as an amusement for the rich who could afford large and expensive yachts with professional crews, by the end of the nineteenth century sailing was becoming popular among those on more modest incomes. Sailing clubs for this new breed sprung up everywhere, with one at Castle Cove, next to Sandsfoot Castle, founded by Weymouth bank clerk Mr A. D. Hownham-Meek in 1923.

Local sailing shot to prominence in 1960 with the filming of *The Bulldog Breed* starring Norman Wisdom as Norman Puckle trying to deliver groceries to the Navy from a Castle

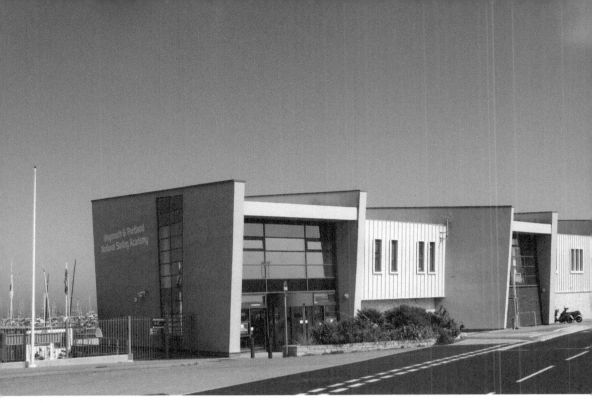

Above: Weymouth and Portland National Sailing Academy

Below: 2012 London Olympics sailing legacy.

Cove dinghy. With *Dalton's Deliveries* emblazoned on his mainsail, Norman inevitably caused mayhem and ended up being run down by a frigate.

Getting in the way was ever a problem for all who sailed in Portland Harbour in its naval heyday. So was avoiding the Whitehead torpedoes, which were regularly, and sometimes erratically, fired on tests – fortunately without their explosive warheads attached.

After the closure of the naval dockyard in 1995 and the helicopter base in 1999, the harbour was reinvented as a commercial port and the land to the west developed for other maritime businesses, including the Weymouth and Portland National Sailing Academy, which was founded in 2000.

New facilities were opened by Princess Anne in 2005 and, after the award of the 2012 Olympics to London was announced, major developments continued including adding a small breakwater, pontoons and slipway. Since then, the academy has provided world-class training for wind-surfing and sailing competitors with Weymouth- and Portland-based Nick Dempsey, Saskia Clark, Hannah Mills and Giles Scott winning silver and gold medals at the Rio Olympics in 2016.

Whatever debate there may be about some aspects of the legacy of the 2012 Olympics, (don't mention the traffic lights!) there can surely be no doubt that the new sailing facilities have been a wonderful winner for the town.

Acknowledgements

The pictures of Portland House are by Mike Henton/National Trust. The painting of Sandsfoot Castle is by Winston Megoran. All other pictures are by the author or are from the author's collection. Background research has been greatly aided by the Royal Commission's 1970 *Inventory of Historical Monuments in Dorset* together with books by Maureen Attwooll (née Boddy), Brian Jackson, John Lucking, Nikolaus Pevsner, Eric Rickets and Jack West.

About the Author

John Megoran grew up in Weymouth and attended Holy Trinity and Weymouth Grammar Schools before going on to take a degree in chemistry at King's College London University. As a teenager and undergraduate, he spent his summers working aboard the Weymouth-to-Channel Island ferries *Caesarea* and *Sarnia* and, after taking a waterman's licence and Trinity House pilotage licence for Weymouth and Portland, sailed as mate of the 150-passenger vessel *Weymouth Belle* on her trips to Lulworth Cove and Portland Bill.

After graduating, John then studied music at the Guildhall School of Music and Drama and, for a short while, earned a living as a professional singer performing Gilbert and Sullivan at the Barbican and opera and oratorios in London and on tour.

After that, he returned to his first love of ships and the sea, putting the coal-fired paddle steamer *Kingswear Castle* back into service in 1985 and running the business as well as sailing as the steamer's principal captain for nearly thirty years.

John Megoran is a freeman of the City of London, a fellow of the Royal Society of Arts, and a trustee of the Maritime Heritage Trust and the paddle steamers *Waverley* and *Kingswear Castle*.